MW01173534

LETTERS FROM
AN OTHER

Lise Gauvin

Translated by

Susanne de Lotbinière-Harwood

The
Women's
Press

Originally published in French as *Lettres d'une autre* by
Editions de l'Hexagone, Montréal, 1984.

CANADIAN CATALOGUING IN PUBLICATION DATA

Gauvin, Lise, 1940-
 [Lettres d'une autre. English]
 Letters from an other

Translation of: Lettres d'une autre.
ISBN 0-88961-126-2

I. Title. II. Title: Lettres d'une autre. English.

PS8563.A88L4813 1989 C844'.54 C89-094953-0
PQ3919.2.G38L4813 1989

Copyright © 1989 Susanne de Lotbinière-Harwood

Cover photograph: Susan Ashukian
Cover design: Christine Higdon
Revision and editing: Wendy Waring
Copy editor: Margaret Christakos

Printed and bound in Canada

1 2 3 4 1993 1992 1991 1990 1989

Published by
The Women's Press
229 College Street No. 204
Toronto, Ontario M5T 1R4

This book was produced by the collective effort of
The Women's Press and was a project of the Translation Group.

The Women's Press gratefully acknowledges financial support
from the Canada Council and the Ontario Arts Council.

Preface

Few books seem so obviously to have been written for their 'second' public as this one. The vantage point of a mythical Persian come to survey Quebec culture in the Eighties is strangely enough not terribly foreign to English Canadians. After all, English Canadians have been sending intellectual reporters to French Canada for generations and the resulting essays, novels and translations now make up a rich literary tradition. But Lise Gauvin's *Letters From An Other* adds some unexpected twists to this tradition; her Roxane captures with passionate intelligence both the glittering surfaces and the inner contradictions of a culture in movement.

The Quebec Roxane describes to her best friend Sarah in these thirteen letters is a territory fast taking on new shapes. Its geographical space extends from Montreal through the bucolic islands of the Saint Lawrence as far as New York; its cultural space is dominated by literary modernism and feminism. Most significantly, Roxane's map of artistic practices is given against a backdrop of the power relationships which sustain them: the tensions between small and large cultures, the inequalities of Quebec and English Canada, the subtle conflicts which mark the continued subordination of women in a supposedly emancipated society. Her letters address not only that persistent puzzle what is Quebec? but – a question certainly as difficult – what is culture today?

Lise Gauvin has been attentive to these two questions for many years as an analyst of the literary institution in Quebec and increasingly as a spokesperson for Quebec studies abroad. Her long association with the rich world of literary journals in Quebec (she wrote a book on the *Parti pris* movement and has been associated with *Possibles,* an important cultural journal, for many years) has no doubt been crucial to

5

her understanding of culture as a world in movement, as an often contradictory and diffuse confrontation of practices and ideas.

Had Gauvin's Roxane been writing in the Sixties or Seventies, she would no doubt have traced the contours of a society tensed towards the future, a society where art and cultural forms were markers of progress towards a collective goal. Certainties came easier then . . . ('We were freer then' is the nostalgic and ironic refrain of Gail Scott's novel *Heroine*). But the Eighties have brought Quebec perhaps more than its share of postmodern doubts, suspicions that attack all attempts to describe a 'nation' or a 'culture' in a unified way.

And so Roxane shows that one of the few possible ways today to answer the difficult questions she's taken on is in the fragmented, tentative manner of letters. By borrowing the framework of one of the most celebrated exchanges of letters in literary history (as well as a work sometimes interpreted as a feminist manifesto), Montesquieu's *Persian Letters* (1721), Lise Gauvin builds her exchange on the accumulated historical resonances of her predecessor. The allusion to Montesquieu reminds us not only of that agreeable fiction by which a stranger supposedly sees more clearly into an alien culture than into his or her own, but also of the way Orientalism (as discussed by Edward Said, notably) has come to represent the dynamics of power which inevitably inform our knowledge of other cultures. Most importantly, though, Lise Gauvin's choice of Roxane as the enthusiastic and affectionate narrator of these letters becomes an act of historical retribution. The heroic Roxane, whose only power in Montesquieu's letters was to denounce her betrayer and declare her own suicide (she speaks only at the very end), here takes on a typically modern form of power: the power to interpret and therefore to create meaning.

This framework for *Letters From An Other* brings into play an interesting tension between proximity and distance. We

read the letters with the schizophrenic awareness that they are a product of intimate knowledge of Quebec society coupled with a deliberate effort to see this society from afar. They treat us as well to a mode of description which falls between the whimsical and the scholarly (as in the description of Quebec as a society of consumers which has a 'tradition of novelty'), which is informed and yet gives free rein to the emotions. Roxane does, let us not forget, express some bitterness and not a little frustration with certain aspects of Quebec society.

We could probably summarize the various sources of Roxane's anger by saying that she has little tolerance for relations of dominance – whether they be public and political (Quebec's dance of courtship with Canada) or private and political (the continued inequality of women in heterosexual couples). As far as the first case is concerned, Roxane thinks that if she were to stay in Quebec she would certainly choose to support Quebec's independence. Here Roxane is defending not only Quebec's right to full political expression but also the rights of 'small cultures' in general against the ever-growing forces of global hegemony.

Roxane's view of the 'emancipation' of women in Quebec is on the pessimistic side. Attentive to the contradictions between the real strength of feminist culture and writing in Quebec and what she perceives as the continued deference of many women (who ought to know better) to their spouses' careers, Roxane goes so far as to compare Quebec women to the 'veiled silhouettes' of Iran. Her anger reminds us of the many obstacles which continue to separate women in Quebec from real equality.

The picture Roxane drew of Quebec in 1984 remains to a large extent true now. Perhaps the main element which she would add today, were she to write a sequel to her letters, would be the increasing cultural significance of ethnic minorities. As for the language issue, the most appropriate commentary is undoubtedly 'plus ça change '

7

Roxane's position as an 'outside' observer gives her important insights into the density of the language issue in Quebec. While she includes some aspects of the question in a classical political framework of Quebec's dissatisfactions with Confederation, she also focuses on the 'suspicions' with which feminists especially have come to view language. The language issue, we learn, reaches to the very roots of individual and collective expression in Quebec.

As a translator and feminist theorist, Susanne de Lotbinière-Harwood is especially aware of the exclusions which language can embody. In her writing she has contributed to an understanding of the translator – the feminist translator, in particular – as necessarily an active participant in the creation of meaning. Her use here of the unexpected term *Québécois-e* (a grammatical innovation) becomes a sign of the hybrid nature of the translated text as well as a deliberate affirmation of the femininity often occulted in language. Throughout this text, we are reminded of the triple play of origins which informs the work and of the multiple readers it brings to life: Sarah, the recipient of these letters, has moved from Persia to Quebec and now to the English-speaking world. These successive dialogues suggest the possibility of ever-expanding fictions

Sherry Simon
Département d'études françaises
Concordia University

8

About the *her* in other

Dear reader,
Just a few words to let you know that this translation is a re-writing in the feminine of what I originally read in French. I don't mean content. Lise Gauvin is a feminist, and so am I. But I am not her. She wrote in the generic masculine. My translation practice is a political activity aimed at making language speak for women. So my signature on a translation means: this translation has used every possible feminist translation strategy to make the feminine visible in language. Because making the feminine visible in language means making women seen and heard in the real world. Which is what feminism is all about.

You've probably heard about things getting 'lost in translation.' Here some things have been added in translation. For example, and most visibly, while Gauvin generally uses only *Québécois*, the generic masculine form, I've used *Québécois-e* and *Québécois-es* whenever it appears as either a singular or plural noun. The hyphenated form is feminized French. (Reduplication – *Québécois/Québécoises* – appears in the translated text whenever it does in the original.) This gender-marking strategy may seem strange to you (it is!) because it uses a source language feminization strategy to inscribe the feminine in the target language (English) text. As you read, it will constantly confront you with its otherness. You won't be able to forget that this is a translation. Elsewhere, I've written *voyeure,* the silent *e* being the grammatical mark of the feminine in French. I hope you'll **feel** a difference, even if you don't know this rule.

When the English referent is female – feminists, women – I don't genderize *Québécois*. But if the source text is referring

9

to, say, Québec women writers, I mark this by writing-in the feminine plural: *Québécoises* writers.

The decision to keep the French spelling for Montréal and Québec throughout this translation is also a way of foregrounding the foreignness of the text, but it is not a feminist strategy. Instead, it is prompted by a desire to retain the presence of the 'small culture' in a text translated into the 'large culture' language.

English is said to be grammatically neutral. This is an optical illusion. Language is never neutral. Like other male-made languages, English is a 'he/man' language, i.e., it uses 'he' and 'man' as generics (Wendy Martyna). I've employed several feminist strategies to avoid speaking in the masculine. Translating *la victoire de l'homme* as '*our* victory over the elements' (First Letter), and not assigning gender to animals, so that a plover sends not *his* but *its* greetings to Roxane's friend Sarah (Seventh Letter), are two examples. In one sentence the 'neutrality' of the first English referent ('lovers') made it easy to feminize the following one through reduplication: 'forest-lovers . . . like fairytale heroes and heroines . . .' (Fifth Letter), a strategy I like because it lets us see the feminine in full form.

Conversely, I avoided generic malespeak by specifying when to read the masculine as such, instead of as the all-embracing neutral. For example, I inserted 'men' in parentheses after the words 'while they (men) . . .' because in this particular sentence, Gauvin/Roxane is referring exclusively and specifically to *ils,* masculine plural, which a simple 'they' would not make clear.

I sometimes resorted to the customary strategy of adding 'female' to nouns – 'a female Robinson Crusoe' for example, where Gauvin cleverly feminizes the name itself, creating the neologism *Robinsonne* (Seventh Letter). My lexical strategies included choosing the word 'fatherland' to render *patrie,* which has the same Latin root as 'patriarchy,' something 'country' or 'homeland' does not convey.

'Women quote one another, it's well known,' writes Gauvin as Roxane. Indeed, the feminist intertext is essential source material for anyone translating feminist work. To translate the difficult '*l'écriture-femme*,' I turned to Carolyn Porter and Carolyn Burke's translation of French psychoanalyst Luce Irigaray, where '*parler-femme*' becomes 'speaking (as) woman.' Porter and Burke's text inspired my 'writing (as) woman' (Twelfth Letter). What I'm saying is that to translate feminists you have to read feminists.

Because English possessives agree with the gender of the possessor, they are useful in making the feminine visible. In this translation I used 'her/his' or 'his/her,' depending on source text meaning. But when the source text did not command a particular order, I put the feminine first to establish a logic that disturbs y/our 'androcentric reading posture' (Rachel Blau Duplessis). Doing so was possible because the context of this translation/publishing venture is feminist. 'Her/his' is also justified by alphabetical order, a good logic to use in replacement of the patriarchal order, where the masculine forcibly rules **and** precedes. This strategy is quite readily agreed to by employers because it seems more 'objective.' When an English possessive followed a genderized form – 'every *Québécois-e* artist feels that his/her work . . .' for example – I put the masculine first because this order is already established by the qualifier. But when Gauvin is quoting a male writer, I used only he or his. Otherwise, I would be misleading you into thinking that the text was originally written in feminized French. This is further illustration of how the translation context, which includes the author's gender, determines the degree of feminization appropriate for each text.

When the grammatical code is mute, the typographical code can be used to mark gender. Parentheses allowed me to counter the language practice known as neutralization, which merely erases the feminine ('stewardesses' replaced by 'flight attendants'), by letting you know clearly that the flight atten-

dants Gauvin is describing are '(women all).' Textually and politically, it was important to mark this fact, something French does simply through grammatical gender agreement ('*les hôtesses*,' Fifth Letter). In the Tenth Letter, I used quotation marks twice to highlight the inadequacy of male-made language for speaking in the feminine. Once to emphasize the ambiguity of saying 'fellow' female students, and once to point up the absurdity of women being referred to as absolute 'masters' of the kitchen.

As you can see, there are many ways of tampering with language to make even a so-called neutral tongue womanspeak. I hope these few words about my reading and re-writing of Gauvin's text into English contribute to your own reading of it. And convince you that translation is an act of linguistic invention which often enriches the original text instead of betraying it.

And now, the translator's task completed, she takes a bow and disappears into the alphabet, leaving you to the pleasure and the *plaisir* of these letters.

<div style="text-align:right">

Susanne de Lotbinière-Harwood
August 1989

</div>

One thing has often astonished me, and that is, that these Persians seemed often to have as intimate an acquaintance as I myself with the manners and customs of our nation, an acquaintance extending to the most minute particulars and not unpossessed of many points which have escaped the observation of more than one German traveller in France. This I attribute to the long stay which they made, without taking into consideration how much easier it is for an Asiatic to become acquainted with the manners and customs of the French in one year, than it would be for a Frenchman to become acquainted with the manners and customs of the Asiatics in four, the former being as communicative as the latter are reserved.

Montesquieu, *Persian Letters*,
Introduction,
translated by John Davidson
(London: George Rutledge, 1891)

FIRST LETTER

June

I will, dear Sarah, spare you the latest hardships of a winter
that was apparently nothing out of the ordinary here, but that
kept me in a state of constant amazement with its unpredict-
able fits and starts. We'd hardly had time to recover from a tor-
rential downpour when an intense cold snap came and froze
the ground, which was still not quite free of the brownish
mixture of mud and salt which, in this country, represents our
victory over the elements. So very different from the peaceful-
ness mixed with enthusiasm that greeted the first December
snowfall! But now a certain lushness has overcome the deso-
lation, and it's all happened so quickly that I sometimes feel as
if the leaves and flowers came out before their own buds.
Have faith in summer, they tell me. You know how I love to
laze about in the sun, so you'll understand how readily I can
be seduced by this promise of a familiar season. I've even
started spending time at the outdoor cafés where, day and
night, countless *Québécois-es* who've suddenly become idle
and talkative spend all their time just 'hanging out,' as they
say.[1]

I'll tell you later about those sights and sounds. Actually,
you might find that less interesting than the more exotic – for
you – story of a *Wild to Mild* winter during which I stayed too
cozily bundled up in my apartment despite my need to be out
meeting people and doing various things.[2] The studies I'm
doing don't require a lot of getting around, so I spend the rest
of my time trying to come out of seclusion and to open my
eyes to my surroundings. But living alone, I quite easily suc-
cumb to the lure of television. In fact the word 'lure' only
poorly conveys the kind of curiosity which, though forever
disappointed, kept me glued to the screen all winter.

15

Sandwiched between the French-dubbed version of an American film and weekly episodes of a locally-produced prime-time soap, I saw, in an elaborate setting worthy of our *A Thousand and One Nights,* people of undeniably bourgeois – if not aristocratic – description, drinking Sanka decaffeinated coffee and praising its excellence. Then came the sports crowd – marathon runners, fishing buffs, amateur mountain climbers – expertly combining the pleasures of physical activity with the enjoyment of a well-known brand of beer. While the evening news brought me the most recent world disaster or the latest government deficit almost 'as it happens,' the more select Sunday programming took me from Johnny Halliday to Yvon Deschamps, a top Québec *monologuiste* whose humour is bleak if not biting, from a Sartre play to original productions.[3] One told the story of two lesbians, whose ultimate fate is punishment, against a backdrop of seductively aesthetic images of English gardens and a muffled world, surrounded by servants (I heard a 'Nicole, get me my slippers!' I wouldn't have dared to utter in Persia). Another related the inner drama of women whose profession was to help old people cross over into the other world by inventing refined little pleasures for them. They were called *les passeuses* (from the verb 'to pass' – ferry-women, in other words!).[4] In both cases, visions of the sea, of islands and of fine white sand signified Paradise lost or found.

Sarah, you know as well as I do that, in our circles in Persia, women's liberation is still too recent to be considered a given, but I couldn't help thinking that something here smelled of censorship, or of the sexism we and our mothers have known all too well not to recognize immediately. I also felt, as I watched those dazzling images, that real life was always somewhere else, and I wondered if the playwrights weren't experiencing some difficulty in creating a fictional world truly their own.

That's as far as I got with my ruminations before Radio-Québec, the 'other' state-run network, confronted me with a

shocking film called *Le Confort et l'indifférence* (Comfort and Apathy). Denys Arcand, the film's director, had tried to represent the *Québécois* people's attitude towards political debate, and more specifically towards the Referendum.[5] Not The Sound and the Fury, not Sorrow and Pity, but Comfort and Apathy. As if suddenly all of the violence we heard so much about in the Sixties and Seventies – it even found its way into our local newspapers, Sarah, remember? – had been re-absorbed into a kind of indifference strewn with flashy gadgets and a complacent fatalism. I may still be too influenced by our weighty millenia, even though I feel quite distant from all that now, but it seems to me that the civilization I'm presently immersed in is geared to the short-term, the here and now. Marked by the lack of long-term goals implying duration. Small wonder that the most successful businesses here are the ones whose signs bear this password: *dépanneur.*[6] The grocery store where I used to shop has suddenly become a *dépanneur fruits et légumes.* The bank I used to do business with was also forced to flee from an arrogant *dépanneur*-grocery. On every street corner, and even in remote rural areas, they are springing up like mushrooms, always ready to help you out in a bind. Are the people of Québec really so incapable of planning ahead that they must constantly resort to stopgaps in order to ensure their survival?

To an extent, in this little country with the status of province, continuity inspires fear. It seems that at one time, there was an era of almost complete stagnation, when being *Québécois-e* meant safeguarding traditional values, i.e., religion, language and tradition. Any change was taboo, any incursion from the outside a threat of impending perdition. Then came a massive clean-up and a drive towards industrial recovery. The old rocking cradles were dusted off and stripped to the point of becoming unuseable, and soon resembled harmless knitting hampers.[7] Churches turned into bingo halls, country schools gave way to huge *polyvalentes*

where they prided themselves on providing special education as early as the ninth or tenth grade.[8]

The reason I'm telling you all this, Sarah, is that I'm trying to understand for myself what is happening today, as we witness the trend towards a kind of overlapping of the two tendencies I've just described. On the one hand the defenders of heritage relentlessly dredge up anything that might have some historical, ethnological or architectural value. On the other are the advocates of modernism who, in louder and shriller voices, criticize those whose vision can't help but be filtered by the blinders of folksy attic windows. I could be wrong, but I'd say that both these extremes stem from the same tenacious feeling of self-reproach all too reminiscent of the reflex often found in colonized peoples.

Are they forgetting that in big cities like Paris, where you and I spent some time together, the universal can only be conceived of insofar as the agglomeration of villages making up its core and its periphery are taken into account? Can you imagine any well-known artist or creator who hasn't tested his or her roots, if only to experience the process and then transcend it? You know as well as I do that capital cities are far too intent on difference not to be astonished by certain local folk whose internationalist pretensions and eagerness to keep in step with current trends and empires lead them to completely leveling out that very difference. But I'm wandering a bit here, and may be boring you with all this? Please don't think for a minute that I'm advocating a return to traditionalism of any kind – you and I both know full well where this trend has led modern Persia.

Yet I just can't help feeling puzzled by the speed with which fads and trends replace one another in this country where, I'm told, a ten-year span is enough to see a generation rise and fall. In your last letter you asked about the state of popular music, those songs that first introduced us to a place called *le Québec*. Well, as far as I can tell, that intimate yet collective

expression now seems to exist mainly in the memory of a certain generation. For the others, it has been replaced by rock or disco. Some friends and I recently attended a concert by the three greats – Félix Leclerc, Claude Léveillée and Gilles Vigneault. It was a special evening, a benefit organized to save a theatre in Québec City. Ticket prices were high enough that the audience was fairly middle-aged, if not respectable. But there was nostalgia in the air and I wondered if the current disaffection for politics didn't have a parallel in the one for this music. As if the homeland (*le pays*) so often mentioned and sung about had already sufficiently come into being for a feeling of saturation to ensue. Among the greats of the Sixties, only Charlebois seems to have retained his popularity. The others have been coopted by the folk heritage which, in various milieux, it is good form to scorn these days. But I've heard a lot about the outrageous performances Diane Dufresne gives, and I hear Fabienne Thibault's golden voice regularly on the radio. A woman friend also loaned me Suzanne Jacob's records: I can't get enough of her heartfelt music, which has nothing in common with the triteness of some of the current hits whose titles I've already forgotten.

After spending a few weeks drifting along on these impressions – shaped by my chance encounters and wanderings – I felt the need to find out more about what *Québécois-es* dream and write about. I went for a walk on a busy commercial street in search of a bookstore. Spotting some books in a storefront window, I went in, only to realize a few seconds later that I'd entered a chain drugstore whose book section was comprised uniquely of cookbooks written by worthy representatives of religious orders who have, apparently, made this line of work a specialty with a responsive market. Continuing my walk, I noticed a stationery store proudly advertising the latest bestsellers by John Irving and Jeanne Bourin.[9] Feeling on familiar territory this time, I browsed through the magazine racks, where I couldn't help noticing the high percentage of periodi-

cals devoted to interior decorating or to that male invention called pornography. Then, after admiring the wide selection of greeting cards, I asked the woman who seemed to be in charge of selling both stamps and cigarettes if she had any *Québécois* books to recommend. She pointed to the confessions of a female ex-politician and smilingly informed me that this was not the place to be looking for *Québécois* literature because 'I can't afford to keep unsold stock around for very long, you see. Most people who come in here are looking for a sure thing so, along with newspapers and magazines, they buy only international bestsellers.' I asked her to pray tell me where I could find this mysterious Québec literature. She gave me the name of a specialized bookstore two streets away. I rushed over. Imagine my dismay when I found the place deserted! A sign said the bookstore had recently been forced to close and that a lighting store would soon occupy the premises.

So I decided to check the phone book, and found the address of another bookstore not too far from my neighbourhood. In a sub-basement lined with books, I was shown a section of *Québécois* works under the label Canadiana. Taking the owner's advice, for she is very nice, I bought a dozen recent books and left the store with this first harvest. I've often returned to this address, for the owner and I have developed a kind of complicity where we exchange comments about the books we've read. And I have sometimes been the one who has introduced her to texts she would not have read otherwise.

So this is how I discovered *Québécois* literature, beginning with the end, that is, with contemporary production. My research on recurring archetypes and characters in nineteenth-century tales had till now informed me only about a very specific and, all told, rather repetitive type of narrative.

What I've read has left me with an impression of great diversity. Knowing how I love stories, you'll understand how

much I delighted in a cat-tale disguised as a detective novel (*Dear Neighbour* by Chrystine Brouillet) and in the tribulations of Yves Beauchemin's *The Alley Cat* subtly woven into the fabric of everyday life in Montréal.[10] I also plunged into Louis Caron's historical sagas, Yves Thériault's fast-paced tales and Victor-Lévy Beaulieu's lyrical lamentos. I also discovered a Jacques Godbout skilfully handling ambiguity by inventing the two-headed status of *Les Têtes à Papineau.*[11]

This last novel is worlds apart from the ones previously named. While they are willing to follow the thread of a story line and plot, thus tying into the oral tradition, Godbout, loyal to what I would call Sixties' tendencies (from what I can gather from conversations and discoveries), steers clear of a certain reading pact and breaks up his plot so that all that remains is a fragmented puzzle, left open to perplexity or to the reader's playfulness of spirit. A destructured narrative which can be traced directly to the Canadian historical fable and which foils its fictional strategy by naming it. It is given the label 'literature of the in-between,' though not as arduous as Hubert Aquin's, which I obstinately and conscientiously insist on reading. In between novel and essay, in between the temptation to and the refusal of narrative, in between the *nouveau roman* and the explanatory anecdotal story, *Les Têtes à Papineau* or: On the impossibility of having a mind of one's own when one has two.[12]

Yet creators here seem to deal rather well with this cephalalgia.[13] After loudly reclaiming the epithet '*Québécoise*' they absentmindedly accept the possibility of a Canadian culture decreed by the centralist government in Ottawa. The notion of Québec's specific character has often been likened in my presence to the struggles of a nationalistic rear-guard. It is tolerated like a great weariness. A necessary evil. An epic tale which should already have unfolded. A challenge to universality and to modernism. In a 1973 novel by Réjean Ducharme, two young people spend their time between

proofreading jobs casting a weary eye on the worlds of politics and entertainment. This attitude seems symptomatic of an entire generation. But sticking to this diagnosis would be both misleading and superficial. From now on, the writer refuses to submit his or her critical subjectivity to any recruitment or cause, and is more concerned with how to be a writer than how to be a *Québécois-e* writer. The age of speech comes about through the 'I' of singular, concrete experience. For contemporary creators, it is no longer possible to be the standard-bearer of an undifferentiated 'we.' An incisive if sometimes caricatural essay by François Charron expresses this difficult tension of 'I' versus 'we':

> The writer's task has always been, in some way, to maintain a distance, one which is always difficult (and ultimately unbearable), with that network of Meaning, of Nationalism, and of Power. Given the current climate in Québec, it seems to me that he must, all at once, and with renewed tension, fight for this political recognition of the French fact, of Québec's political autonomy all the while maintaining a radical refusal: that this much sought-after or found recognition not get frozen as a compulsory knowledge of behaviours, of culture. He must gamble not only for a liberation of 'collective memory,' but also, and especially, for the liberation of that individual memory lodged in everything that obsessively roots him to a Land where the dead bequeath unto him their inhibitions and their feelings of guilt *(La Passion d'autonomie)*.[14]

Individual memory is the memory of an unconditional commitment to the here-and-now writings of transgression and constant risk-taking.[15] These writings I've learned to recognize thanks to the women's texts I've been discovering. I avidly read and re-read Nicole Brossard's *These Our Mothers*

and *Surfaces of Sense,* admiring in her work the nervous density of language that allows meaning to be shattered.[16] Madeleine Gagnon teaches me to lift the veils covering the discourse of the unconscious while with Louky Bersianik, I share in singing an unsung *Maternative.*[17] With Yolande Villemaire I disappear into the teeming unpredictable urban beat of *La Vie en prose,*[18] I recognize myself in France Théoret's subtle verbal violence, and let Madeleine Ouellette-Michalska guide me in locating the stigmas due to a condition (*L'Echappée des discours de l'œil*).[19]

This speaking-out by women, both vehement and tender, prospective and immemorial, is what I find by far most interesting in contemporary *Québécois* literature. And I don't consider this sexist bias on my part. In their work I am simply discovering a freedom and a power we are still very far from, in our country. This is what makes it so attractive to me. The women writing here have struck the difficult balance between autobiography and fiction, between the singular and the collective. Each one of their texts is an invitation extended to the reader to continue the journey on her own.

I'm well aware, Sarah, that I've said too little in this overly long letter for you to fully grasp what is going on here. You can always fill in the gaps of my literary overview with Jean Royer's latest book of interviews, *Entretiens* – which I'm sending you under separate cover – it's an excellent introduction to contemporary writing.

You'll probably have noticed that there is nonetheless more fervour than gloom in this Québec, more enthusiasm than disenchantment, even though the current crisis in development has grafted itself onto a permanent identity crisis. I've scarcely begun to list all the contradictions and strangeness of this country, still tenuously anchored to the North American continent, and still trying to find a voice of its own without falling into the closed circuit of nostalgia. But it is a homeland constantly traversed by a baroque carnival atmosphere which

Jean-Pierre Ronfard's *Vie et mort du roi boîteux* cycle brilliantly restores on the stage. It never ceases to amaze me, and I feel farther than ever from finding the answer to the question I started with: 'How can one be *Québécois-e?*'

I hope you'll accept my invitation to come and visit for a few weeks very soon. You'll see that I live quite well thanks to a Canadian government grant. You can also expect a warm welcome, for *les Québécois-es* have the kind of natural heartiness that makes them regard any interested foreigner with friendliness.

> Looking forward to hearing from you,
> Your faithful friend,
> Roxane

Translator's Notes

1. Throughout this translation, *Québécois-e, Québécois-es* will be used in reference to native French speakers in Québec. The terms 'Quebec Anglophones' or 'Quebeckers' will refer to its English-speaking Anglo-Saxon population. *Québécois-es* is the non-sexist grammatical transcription comprising both genders.

2. Réjean Ducharme, *L'Hiver de force* (Paris: Gallimard, 1985). (First published in 1973.) *Wild to Mild*, translated by Robert Guy Scully (St. Lambert, Qué: Editions Héritage, 1980).

3. Yvon Deschamps: Elvis-style French rock idol popular in the Sixties and early Seventies. Here, as is sometimes the case elsewhere in this translation, the adjective 'French' means European French, from France.

4. The words in parentheses are mine.

5. Referendum: May 20, 1980. The question put to the people of Québec asked if they wished to grant the government of Québec permission to negotiate *souveraineté-association* from Canada. The answer was No by a majority of 60 percent to 40 percent.

6. From the verb *dépanner* – to get someone out of a jam, to help them out of a situation. *Panne* means engine failure or power blackout.

7. Allusion to *la revanche des berceaux,* the revenge of the cradles, a demographic strategy deployed by French Canadians to fight British colonization. Having huge families ensured the survival of the race, the religion and the language.

8. Comprehensive high schools.

9. Jeanne Bourin, best-selling French author of historical novels such as *La Chambre des dames.*

10. Yves Beauchemin, *Le Matou* (Montréal: Québec/Amérique, 1981).
 The Alley Cat, translated by Sheila Fischman (Toronto: McClelland and Stewart, 1986).
 Chrystine Brouillet, *Chère Voisine* (Montréal: Les Editions Quinze, 1982).
 Dear Neighbour, translated by David Homel (Toronto: General, 1984).

11. Jacques Godbout, *Les Têtes à Papineau* (Paris: Seuil, 1981).

12. *nouveau roman*: the new French novel of the Fifties which defined a type of writing and brought together a certain group of writers, including Alain Robbe-Grillet and Claude Simon. It broke with the classical narrative novel

tradition, replacing it with a series of constructions and deconstructions as well as with object descriptions which earned it the appellation '*école du regard*' (school of the gaze).

13. cephalalgia: headache. From *cephalos*, 'head,' and suffix -*algia*, 'pain.'

14. François Charron, *La Passion d'autonomie* (Montréal: Les Herbes rouges, 1982). Translation mine.

15. writing(s): in French it is common nowadays to pluralize the word writing, *écritures*, the same way we speak of 'feminisms.' It's a way of indicating that attention is being paid to context. This usage can be seen as a feminist reclaiming.

16. Nicole Brossard, *L'Amèr ou le chapitre effrité* (Montréal: Les Editions Quinze, 1977). *These Our Mothers, Or: The Disintegrating Chapter*, translated by Barbara Godard (Toronto: Coach House Press, 1983).
Nicole Brossard, *Le Sens apparent* (Paris: Flammarion, 1980). *Surfaces of Sense*, translated by Fiona Strachan (Toronto: Coach House Press, 1989).

17. Louky Bersianik, *Maternative* (Montréal: VLB Editeur, 1980). The title is a neologism invented by Bersianik, composed of *maternité* and *alternative*.

18. Yolande Villemaire, *La Vie en prose* (Montréal: Les Herbes rouges, 1980). (No translation exists although one titled 'Life through prose-coloured glasses' was undertaken a few years ago but never completed.)

19. Madeleine Ouellette-Michalska, *L'Echappée des discours de l'œil* (Montréal: Nouvelle Optique, 1981).

SECOND LETTER

December

If I've neglected you these past months, I'm sorry, Sarah, and I promise to be more faithful in future. Don't go thinking I'm forgetting you. Quite the contrary. In my mind I'm constantly sharing my astonishment, my blues, my questions with you, inwardly reaffirming the unspoken pact we sealed years ago with our games and our pranks. Too often I use my natural laziness and my restlessness as excuses for not writing. Will you forgive me if I tell you that I am the main victim of this silence?

Today I'm taking you to Québec City, one of the major arenas of the French Conquest of North America. Follow me closely and I'll tell you everything. But first, please brace yourself for the rite of passage taking us to the Voyageur Bus Terminal, that oh-so-dreary place of deadly *ennui*. Between two gusts of wind, sedentary or nomadic vagrants sit and stare, some at a TV set, some at the tall blonde in white fake fur and matching boots, some at The Main's last cowboy, on his way to the yearly back-to-the-roots pilgrimage in Saint-Tite.[1]

I sit down on one of those ridiculous little seats set against the few walls separating the glass doors which split travelers up into chilly and resigned triads. So, stuck between exits 9 and 10, I have time to watch what seems to be this place's customary comings and goings: a man with a grey beard, too upright to be a drunk, carrying his whitish canvas bag around in search of some treasure, a fat woman in slippers who seems lost in the crowd and whose children have come to rescue her, a potbellied civil servant, obviously happy about the meeting he has just attended and dreaming of a better future. And then there are those who are here because it's warmer inside than out, because there are people to see, because there is nothing else to do. It's not the people themselves so

much as the ugliness of these desperately dull surroundings that colours the whole scene with greyness and desolation. We have to come through here, as I said earlier. But let's not make too much of it. The bus for Québec City has just pulled up. We're on our way.

It's December and raining. The scenery disappears in the fog. I bury myself in Anne Hébert's novel *In the Shadow of the Wind* and fall under the spell of her short, dry sentences, that pointillist technique which cultivates astonishment so as to create intensity.[2] Not far from me, a real motor-mouth is telling an obliging stranger his life story; two Inuits in embroidered parkas are smoking; a young Anglophone student is studying the map of Québec City. I brought neither map nor brochure. I prefer to let casual strolls and chance encounters guide my discovery of this famed place. I am going to attend a colloquium on *Langue et Société* and will be meeting up with a *Québécoise* 'of old stock' who will show me around.

The rain has gradually changed to snow, highlighting barren tree trunks along a boring highway. Brighter and brighter lights foretell the city. After crossing an ultra-modern bridge named in honour of an assassinated government minister, the bus passes through the residential areas of Sainte-Foy before stopping at a huge shopping centre where the density of the parked cars is a good indication of the number of transactions taking place inside. My neighbour tells me the municipality is composed mainly of civil servants. I soon realize that there are not one but two, even three, shopping malls, with l'Université Laval on one side and on the other, luxury hotels belonging to large American chains. I confess I'm a bit disappointed. Is the city of Québec nothing but a vast suburb whose heartbeat is regulated by the strength of its buying power? My first impression doesn't correspond to my expectations. But as I've learned to be wary of hasty judgements, I let myself be taken along boulevards lined with insurance companies and

wealthy homes to the terminal in the *basse ville,* the Lower
Town.

There, the perspective totally changes. I feel as if I'm enter-
ing another time, if not another place. A taxi-driver politely
offers to take my bags. Then, his voice drawling slightly and
leaning a little heavily on certain syllables, he asks if I've had a
good trip. On our way to the Upper Town we meet a
caléchière gaily driving horse and buggy back to the stables.[3]
A quick glance at the old walls as we skirt the Parliament
buildings, and here I am at my destination.

[. . .]

The expected enchantment occurred only the next day.
From the sixteenth floor of the luxury residence where I'm
staying, I can see not only the entire city, but also the busy
port and especially the river, already a frozen field of white. A
long cargo ship is cutting through the ice, slowly heading
towards the Gulf as it hugs the south coast of l'Ile d'Orléans.
Another, seemingly motionless, is dissolving into the fog,
leaving a dark gash in its wake. I stood there watching for a
long time, fascinated by the white and grey abstraction.
Unlike Montréal, whose insularity is theoretical, Québec is a
water city, marked by the omnipresence of its great river.
Doesn't this in part explain the slowness, the tranquility and,
to a point, the fatalism a visitor cannot help but notice in its
residents? A city of waters whose particular healing properties
are more likely to help remedy stress than liver ailments or
rheumatism.

Just for fun, I try to understand the city's history through the
configuration of its buildings. What I see leaves me puzzled. I
wish you were here, so we could try to figure it out together.
Two minds wouldn't be too many to analyze all the clashing
couples competing for the Québec City skyline in as many
silent and definitive battles: the Hilton tower and Château
Frontenac, the Parliament building and the Citadelle, the
department of Intergovernmental Affairs' modernist *block-*

29

haus and the little cluster of old houses clinging to the rue Saint-Denis hillside, the symmetrical chimneys of la Grande-Allée and the condos on neighbouring streets.

With its neo-Renaissance style, the Parliament building seems to crown the Upper Town with pride, occupying its whole centre, but a glance to the right reveals the dominance of the Citadelle, guardian of the magnificent Plains of Abraham. Two flags, one with a *fleur-de-lys* and the other with a maple leaf, float over both buildings, and the statue of Maurice Duplessis, ex-Premier of the province, stands face to face with Wolfe's English cannons. The Hilton tower arrogantly overshadows the Château Frontenac's old green roofs. As for the *blockhaus* terrace, it resembles a UFO landing strip, with which no known surface can presently compare. But are these true rivalries? Doesn't this bird's-eye view of Québec City attest instead to a courteous harmony, eclectically allowing the layering of styles and political regimes?

What I hear at the colloquium makes me change my tune, and the whole rest of my trip is nothing but cries and whispers. For a long time now I've wanted to know more about the language issue in Québec. Actually, I don't quite understand why, in a milieu where the large majority is Francophone – though strongly influenced by its North-American environment – no government before the Parti Québécois had ever ruled on the use of French. And I don't understand why Bill 101, making French the official language, has been termed a Fascist, undemocratic measure. My experience of multilingual European countries has shown me that a language survives only when spoken freely in circumscribed areas, away from domination by another language. I read Michèle Lalonde's poem 'Speak White' and numerous statements by writers who, like Gaston Miron, denounced Québec's linguistic alienation, the consequence of political and economic oppression.[4] Given these circumstances, legislating on language seems to me a simple matter of common

sense. This is not the time to sing the praises of French, as was done in the past, but the time to act so that a collectivity of several million people can legitimately express themselves in their own language. Otherwise, they run the risk of becoming mute.

But what really worries me is of another order. I wonder to what extent the linguistic debate and the assurance of being able to live in French from now on haven't, in a way, crystalized the *Québécois-es'* energies and claims. In other words, hasn't what was to be (or what should have been) just a preliminary become instead the overriding outcome of a more general search for emancipation? In which language is just one aspect? An important one, granted, but not the only one. There appears to have been a shift, from the centuries-old link between language and religion towards a religion of language.

In my opinion, the failure of the Referendum rests partly on the fact that, reassured by their daily practice of French, the *Québécois-es* somehow believed they had won the fight, without taking into consideration the fact that the powers which languages depend on continue to elude their grasp.

Langue et Société did not provide any answers. I heard brilliant speeches about *les Québécois-es,* about how the mongrelization and poverty of expression of their language would make them better at mastering computer language. I also heard a well-known writer lamenting the absence of a collective project which, in his view, is reflected in Québec's literature. Is it really that simple? To me, this all seems to circulate a number of clichés which my recently acquired knowledge of Québec could easily contradict. There's a kind of endless self-indulgence here for licking one's wounds and finding them beautiful. For entertaining the ill and the illness. Is what was necessary to provoke awareness in 1960 still necessary today? I confess it's all starting to annoy me a bit. I prefer the soft affirmative voices of women and men determined to face

the present to those of the tenors in an eternally negativist paupers' opera. Suddenly I've had enough of the shrill cries of indignation at this colloquium, I'm going out for a walk. After three days cooped up in windowless rooms, the sight of the Ursulines' monastery on rue du Parloir has a very liberating effect. I go through the walled part of Québec on foot, down the staircase leading from Terrasse Dufferin to the côte de la Montagne and to rue Champlain. The noonday sun singles out the spectacular aspect of this exceptional urban topology, with its backroad village airs. In one of the restaurants located near la Place Royale I join the friend who invited me to Québec. She recognizes a few friends and colleagues. My presence never fails to arouse a few indiscrete and curious stares. News travels fast. Later I find out that whispers are circulating. Who am I?

It's difficult to go unnoticed in this city where everyone is identified through their uncles, aunts, college friends or the neighbourhood they grew up in. Protected and fortified against the problems of foreign domination, Québec is also a city of rumours and of what-will-the-Jones' think? Any *Québécoise* who runs into another immediately inquires as to possible family ties or connection of some kind. This is what my friend explained, adding that the only way to live in peace in Québec City is to leave for a few years.

As you can see, I'm not through discovering this corner of America which both escapes me and escapes all definition. I'm simply trying to understand it, little by little, piece by piece. And hoping you too will find something to interest you in all of my wanderings.

Your ever-faithful friend,
Roxane

Translator's Notes

1. The Main: Montréal's St. Lawrence Boulevard, so-called because it divides the city into East and West. This very busy, multi-ethnic artery plays an important part in Québec literature, film, etc. Quite seedy in parts, it is now the object of much gentrification.

 Festival Saint-Tite: Québec's legendary country-and-western festival, held yearly in the tiny rural town located about 70 miles west of Québec City.

2. Anne Hébert, *Les Fous de Bassan* (Paris: Seuil, 1982). *In the Shadow of the Wind,* translated by Sheila Fischman (Toronto: Stoddart, 1983).

3. *caléchière*: a woman driving a horse and buggy (*calèche*) for summer sightseers.

4. 'Speak White' – meaning 'speak English' – is the title of Michèle Lalonde's notorious 1968 poem decrying the cultural and economic imperialism of the English language in Québec. It exists in English translation by Ben J. Shek, *Ovo Magazine* Vol. 10, no. 39 (Montréal, 1980).

THIRD LETTER

January

I finally saw New York, the Big Apple. Going there was like going to a show, not really knowing what to expect, attracted by its reputation for modernism and internationalism.[1] A recent debate has put New York on the map, so to speak. Pondering over Québec's cultural specificity, the editor-in-chief of *Le Devoir* contends that apart from language and links to the land, nothing distinguishes this collectivity from its neighbours south of the border. Is specificity now merely an outdated notion, an assortment of frozen symbols turned to stereotypes from being used too exclusively and too often: pea soup and bread-boxes, used cradles and *ceintures fléchées*.[2] Could it be that New York is the primary universal cultural referent these days? In this time of internationalism, there is no longer room, according to some, for small, somewhat loosely defined groups such as the one formed by Québec culture.

A lot of my Montréal friends regularly travel to this mecca of art and passion to soak it all up and get re-energized by this city, symbol of all cities and of all contemporaneity. After New York, even Paris seems *passé* to them: modernism there remains too exclusively theoretical, it is still – despite Sollers' abdication – hooked into the engineering of the *nouveau roman* and formalist self-referentiality.[3] Not to mention the fact that any novelty is inevitably muffled and muted by centuries of history. My Montréal friends need a more tumultuous, more spectacular kind of expressiveness, more aggressive or wilder leaps. In short, an intellectuality that operates closer to the senses.

Four of us left in search of this mythic and mythologized city. The first images quite matched our expectations: a cold and sunny January gave us a clear view of the silhouettes of Manhattan's skyscrapers and the Statue of Liberty towering

above countless pleasure craft. At LaGuardia Airport, baggage claim was instantaneous. I felt I was entering a world where things are as light and fast as flashes of the mind. Unfortunately, this world soon deserted us! A more prosaic landing was in store. A rattling broken-down yellow cab took us to a decrepit old hotel on 51st Avenue, where we lodged for sixty dollars American a day, ugly decor and overheating included. Nothing very exciting about this, I'm sure you'll agree. The one positive aspect of this first outing: the shops with fruit and vegetable stands on the sidewalks giving America's metropolis the air of a little European town.

I then visited the sightseer's New York and experienced firsthand those things necessary to the accomplishments of any tourist who prides herself on having traveled a bit: Friday evening rush hour in front of Macy's, the Metropolitan Museum's endless hallways, night life in Times Square, a cocktail party at a French Embassy like any other French Embassy (i.e., with Versailles-like decor), strawberry sherbet for breakfast and, for lack of opera, a stirring musical in which a very mild-mannered Che Guevara comments on Evita Peron's life. I'm rather disappointed with what theatre I did see. I went to *Amadeus,* a famous play about the life and hard times of Mozart. That side of Broadway reminds me of *La Comédie française*: in vain I search for a sign of America or of New York.[4] But in choosing this play I may have yielded too readily to its notoriety and success.

To tell you the truth, only SoHo lives up to the sum of unexpected images I hoped to receive from New York. Next to the 'sure-sellers' offered in Greenwich Village – Miró, Eleonor Fini and the rest – SoHo shops have a deliciously libertine air of improvisation and neglect. But take a closer look and all the codes appear there too. High quality antiques alternate with warehouse-galleries, white china bowls and woven baskets with Indian imports, herbal tea salons with pubs. Much like artists' quarters in any large city where snobbery has moved

in. Nonetheless, something like a paroxysm can be felt in SoHo. Something that can only be defined as the awareness of coinciding perfectly with one's time and of shaping its outline at will. Until further notice or a fresh find, this place has become the recognized locus of the universal. And they know it, too, those provocative aesthetes who, in their disguises and eccentric hair, make up the obligatory setting of these highly seductive streets.

In this vast theatre of contemporary art, the stages are wide and generous. The huge rooms of old warehouses make it possible, among other things, to exhibit farm machinery, bicycles and barn doors (is New York on its way back-to-the-land?) which are transformed into aesthetic objects by the sheer will to frame and isolate them. Other galleries, the low-income housing of culture, concentrate and consecrate, floor after floor, the various strata of visual arts practice. Canada has a place in this *establishment*.[5] Its art gallery, the '49th Parallel,' which exists thanks to federal funding, is notable in that, to date, it has mainly shown work by... Anglophone artists. When I told some people I found this astonishing, they agreed it was in fact an odd coincidence, and that if this were brought to the attention of those responsible, they would reply that quality or conformity with current aesthetics are the only criteria presiding over the choice of works and of artists. How can you accept this situation?, I sometimes ask my friends. Most of the time, they confess, we don't really know what's happening, and when somebody does protest, they say this person is defending their own work, their own interests. The rules of the game are far from clear in this scene. And from the looks of it, no one is trying to make them any clearer either.

I'll leave this slippery terrain behind, my dear and faraway friend, and lead you onto another, equally fragile one – modernism. Shaky ground indeed, where each and every person builds a sand castle that quickly collapses. I've realized that New York has an insatiable appetite for trends. To have a

show in SoHo, do you have to conform to a déjà vu? This would justify certain exclusions – or must you astonish and provoke, by taking a step backward, if need be, and so refuse to situate yourself in a continuum or a recognized aesthetic? I soon realized that this debate is as pointless as the chicken-and-egg question, given the speed with which both get swallowed up before ever seeing the sun's shadow. We are thus pledged to permanent anachronism. No sooner had the minimalists received sanction than they were already *passé* and obsolete, reports a reliable source. No sooner does one area of the city gain notoriety than another springs from anonymity.

I saw a bit of everything there, at the headquarters of international art: from neo-, hyper-, ultra-realism to lyrical, from object-oriented to retro. Through this kaleidoscope of styles, I thought I detected a kind of osmosis between the inward and the outward, one that goes much deeper than art as decor or surroundings. I entered a world where, be it on the walls of buildings, on vehicles or in galleries, I recognized the same graffiti and the same signs. Art being written and openly displayed. Art as manuscripted trace, which would blend wonderfully well with the colourful spontaneity of Haitian murals and tap-tap.[6] The contemporary as restlessness, instability and profusion.

Later on, it was explained to me that we've now entered postmodernism's sphere of influence. By contrast, I'm surprised to notice how fixed the concepts of *la modernité* are for some Québec creators, despite their fascination by the art and example of New York. It's as if they were in the wrong neighbourhood or city, still clinging to some already deserted urban island, or wanted to apply the canons of Parisian modernism to the erratic blocks of America's urban spaces. In Montréal's literary circles, all you hear about is the credo of writing the body, of textual reference, of the non-figurative and of the city. Isn't there something anti-modern in even accepting to

38

make yourself comfortable once and for all in this lap of legitimacy? Sheltered from any self-questioning, and acting as judge and jury in the trial of one's own validation. We are modern, some say, and, the inevitable corollary: modernism is us. There are a few variations on the theme. The first one is: be modern or be damned! The second one is: do as we say, toe the line and with a bit of hard work, you too will enter the sacrosanct halls of modernism. You will then be called a modern author/creator and, owing to some thoroughly modern alchemy in which the epithet overshadows its noun, no one will think to ask if you are in fact an author! For Montréal's very exacting *modernité,* austerity is still preferred to expense, the performative to the performance. Even women's writing is often associated with this precept of rigour, economy and theoretical return on its own discursive practice. But it also knows how to get beyond this new orthodoxy: it knows that there is more than one way to deflect codes and gain access to speech. In quaint, nostalgic, hybrid, excessive SoHo, I couldn't help thinking that there is still time for my country of adoption to learn tolerance, daring and wildness.

In Québec, plurality is lived with the obsession of singularity. For example, people will claim that *la modernité* is plural, yet show difficulty in conceiving of anti- or postmodernism outside a perspective of appropriation or integration. And will even view what borders on modernism with more or less well-disguised contempt. Is this an attempt to link the strange blurring of voices and the current romance with America to the post-May '68 conceptual French 'fatherland'? Again and again, the explanatory grid is dragged out, the 'system' capable of defining the multiple, the varied, the proliferating. Like a never-ending justification of one's existence. And also – this is no doubt of the same order – like a shameful need for consensus.

Have I lost you along the way, Sarah, with this discussion you'll surely find far removed from your personal preoccupa-

tions? I'd promised to talk about specificity. Actually, I haven't much strayed from the subject. New York's cultural specificity stems precisely from the fact that the question never comes up. The city gaily accumulates the sum total of its non-specificities. It doesn't have to declare itself such and such, for no one challenges its right to exist in an international, American or specifically New York way. The *Québécois-es* compulsory specificity is like a response to a constant attack: 'If you want to be, be, but be specific.' List your titles, measure your difference or disappear! Back in 1960, specificity was a political demand and a will to be. A proclamation based on a complex feeling of belonging (*appartenance*) and of otherness.[7] A collective life-wish. A comprehensive contract. All vital and imponderable things which, today, need to be measured as is the acreage of a field or the extent of the damages. Hence the temptation to return to an indisputable specificity, one inevitably addicted to the past. And Québec squanders itself in this derisory negotiation, which is based on a preoccupation with definition that can only be static and retroactive. Which presupposes a gaze that fixes and reifies the other, transforming that person into an object. New York has no need for self-justification. Between a barn door exhibited in Montréal and at Leo Castelli (one of SoHo's major art dealers), lies the gap of suspicion. Montréal's door will be seen as rustic, New York's as modern or postmodern. One barn door – New York's – will be discussed in Montréal's avant-garde journals. Modernism partakes of this presumptive trial-without-judge-and-jury of a culture whose only defence comes through repetition or validation from outside supporters. How can you reinvent life between these two fixed points? I offer no miracle solutions, as you can probably guess. Nonetheless, I notice that there is no lack of motivation to challenge labels and givens. One day I'll tell you all about some works which, because they displace the horizon of expectations, produce a deep change in their audience.

I loved New York. Until then, the notion of imperialism had been a kind of abstract bugaboo for me. Now I understand how closely it is tied to the magnetism of certain places which are capable of establishing the obvious. Just like everyone else, I was bewitched. By the 'involuntary beauty' of this city of contrasts and flashy colours. During this New York January, pink and yellow vied for preference in store windows, punk competed with new wave, sparse hairdos with herbal garden montages, antiques with contemporary galleries. City of a thousand faces possessed of an enormous appetite for the other. Everybody is at home here, for there is in fact nothing easier than considering yourself someone's other. Here, getting lost in the crowd is as appealing as rows of figures which would never have to be totaled, because there would always be a number or an element missing. I myself was one of these missing elements for a few days, and it didn't take me long to figure out that I was also part of the overall structure. What an enticing prospect it is to choose this place as the endgame of one's singularity or as a remedy for a subjectivity sickened by a specificity denied, granted, wished-for.

New York is a city full of breezes where everyone believes their particular difference or the mark of their individual breath can be written in. With a little luck, that breath will be identified with one of the era's ephemeral currents for a while. But, believe it or not, Sarah, I had a sudden urge to leave this overly accessible city to come back to the specific problems of my land of adoption.

The Haitian cab driver who took me to the airport made my return to Montréal immersion easier. When he heard me and my friends speaking French, he ironically greeted us with a litany of '*christ, câlice, tabernacle*' he'd picked up in that '*hostie de ville*,' Montréal.[8] That first exile had left him only with bitter memories of job loss, difficulties with an associate and financial problems. He also added that he had little respect for Montréal's Haitian cab drivers who, or so he had read in a

New York newspaper, were indulging in scandalous behaviour with their female customers. We tried to contradict him, to tell him that the article had to be exaggerated, seeing as we had never even heard of this state of affairs. Nothing doing. He went on talking about his American Eden and about how easily, in a city as huge as New York, he had achieved a satisfying lifestyle thanks only to his resourcefulness.

I landed in Montréal only to observe what, in this season, we tend to call 'snow on French leave.' Does this mean the *Québécois-es* will have to give up the landscape of their identity? That's another question entirely. One I'm having some trouble unraveling for myself, at the moment.

> Till I can see more clearly,
> hugs and kisses,
> Roxane

Translator's Notes

1. In this translation, *la modernité* has been translated as 'modernism.' Unlike the sometimes obscure creations of Pound or Eliot, informed by a search for the universal and a dependence on classical mythology, here modernism and *la modernité* refer generally to the more avant-garde productions of *Québécois* culture in the Seventies and Eighties.

2. pea soup: a staple in French-Canadian cuisine, the expression was often used as an insult by Anglos ('French pea soup/the more you eat/the more you poop').
 used cradles: see *la revanche des berceaux*, First Letter, note 7.
 ceintures fléchées: handwoven multicoloured belts used to tie fur coats or outerwear, worn mostly in rural areas.

3. Philippe Sollers: French writer and director of the avant-garde journal *Tel Quel* which defended a hermetic, self-reflexive, formalist type of literature. He caused quite a stir when he quit to write best-selling novels (*Femmes*, etc.) which returned to more or less conventional Balzacian narrative and to mysticism.

4. *La Comédie française*: French classical theatre, here used in the sense of 'academic.'

5. *establishment*: in English in the text.

6. Haitian tap-tap: reference to the wildly graffitied Haitian buses, so broken-down that they have no more suspension. Consequently, riding on them means getting your behind tap-tapped.

7. *appartenance*: the fact or sense for an individual of belonging to a collectivity, be it through race, country, class, party; this word was widely used in the discourse of the Sixties and Seventies.

8. *christ, câlice, tabernacle, hostie de ville*: common Québécois swear words, all based on religious and Church vocabulary.

43

FOURTH LETTER

March

I confess that, after I first arrived, I wasn't overly sociable. I'm sure you know my departure was prompted, in a very secondary way, by my wish to pursue my studies. It was only once I'd settled in Montréal that I got caught up in the game of poring over old writings, and turned a pretext into an actual goal. In fact, my trip was an escape. One I wished so irrevocable that I've never once asked you about the man I thought of as my fiancé for quite a while. I might never have had the courage to make the break had I stayed in Persia. By leaving I merely hastened the inevitable.

I was also deeply in need of a change of scene. I could no longer bear the exacerbated nationalism beginning to rear its head in our country. A world of tradition and all-male power. In this respect there seems to be no possible comparison between what I experienced back home and what I've seen here in Québec. I'm reminding you of the circumstances of my departure to better explain the kind of distress I was feeling when I chose to come and stay in the only French-speaking place in North America, both to find myself and to lose myself, in every sense of the word. So I arrived here with a fairly open state of mind, fragile and, for this very reason, attentive to the new framework I'd provided myself with.

Having recovered from my initial bout of misanthropy, I made friends with a group of university student-researchers who have started showing me around Montréal. They take me to the theatre, to movies, lend me books and even invite me to the gargantuan feasts they periodically hold in each others' homes. I've come to enjoy these spontaneous parties where wine flows and anecdotes follow till the wee hours. Afterwards, I'm all the more enthusiastic about returning to my books and my painstaking work.

Judging from the encounters I've had with *Québécois* individuals so far, they seem fundamentally carefree and, whatever the situation, little inclined to pessimism. They seem to possess some sort of benign fatalism. They know how to constantly re-adjust daily life to their needs and appetites. Maybe they are all too skilled at putting on a brave face! In any case, they have mastered the art of dry humour – their Anglo-Saxon heritage? – which turns into a self-mockery so virulent it sometimes verges on cynicism. It's as if there was a non-*Québécois-e* hiding inside every *Québécois-e*. As if each person had spent a long time training in the mental gymnastics of being scrutinized by another's gaze and had succeeded in integrating into his/her personality a shifty, multifaceted double. At the slightest provocation, this double is ready to stand apart in disapproval at the slightest sign from the overly-*Québécois* part of its self. Needless to say, this creates some malaise for the foreigner who doesn't quite know whether she is speaking to one or to the other, only to realize that they form an indivisible whole. I've sometimes argued with my friends about this attitude which, in other countries, would be termed self-denigration, if not self-contempt. Foreigners have the habit, they tell me, of agreeing more with their self-rejection. But I dislike this behaviour and make no attempt to hide the fact, even at the risk of being accused of undue interference in affairs that are none of my concern. The European French are ferocious critics of their own institutions and leaders, yet it would never occur to them to dismiss their *appartenance* as readily and as totally as do some *Québécoises*. They seem to sway like a pendulum: no sooner have they asserted something than they immediately take up the opposing argument, which brings them back to a nice balanced standstill. This fundamental duality, which Hubert Aquin likened to the Argentinian tango, could be a source of exceptional dynamism if its very momentum weren't constantly

arrested by a kind of superego formed by the ever-ironic opposite pole.

A survey was carried out recently among several thousand *Québécois-es* from various backgrounds, in vastly different locations and situations. Two questions were asked: 'Who are you?' and 'Who do you want to be?'. Many answers reveal recurring themes that seemingly give credence to notions, if not of a collective *imaginaire,* then at least of an inherent dualistic mental and psychic structure.[1] Hervé Fisher, the French sociologist who conducted the survey, made special mention of the recurrence of the 'bird-cat' pair which, according to him, represents 'that ambivalence between a form of desire aimed at conquest and a nostalgic or bound desire,' 'that existential difficulty of attraction and of obstacle, of the cat's desire which the bird escapes under penalty of death, of the impossible or destructive union of two false friends, of two enemies we willingly associate with each other, as we follow the cat's fascinated gaze towards the edible bird.'

You can guess at the difficulty of getting to know such an ambiguous personality! In my friends and colleagues who are twentysomething, I see an aspect of the personae of Deschamps, whose comic monologues can make the tragic derisory and the derisory tragic; of Sol, the pataphysical clown who speaks poetry; and of Galarneau, the debonair hot-dog vendor in one of Godbout's novels, in love with French-frying and writing, torn between a will-to-speak and an actual speaking ability. In any case, they have clearly left behind the misery-ridden attitude of theatre characters of the Forties like Tit-Coq, who was dispossessed of both his language and his fate. The *Québécois-es* I'm talking about are part of that new international class of educated unemployed, struggling along on grants and occasional contracts, going through the crisis in a climate of general and specific demobilization with a kind of methodical insouciance. While waiting for better times, they

keep busy, specializing in one field of activity, and make the collectivity they are part of – but which they would often like to exclude themselves from – the butt of a merciless critical mind.

I'm told that the previous generation, those who were twenty in the Sixties, was a restless, tormented generation, heir to Camus and Sartre, having read Fanon, Memmi, Berque and given itself the mandate to settle not only the fate of the world but also, notably, Québec's. This generation is still searching for its focus and trying, half-heartedly, to find its little place in the sun. It's as if everything except life's immediate necessities were slipping through their fingers. Who am I to complain? Thanks to the availability of my friends, and to their natural warmth, I've slowly but surely been able to enter circles till then reserved for *Québécois* people only.

Starting with family circles, where I was welcomed with open arms during the Holiday Season. Hospitality is one tradition that remains firmly implanted in the *Québécois* mentality. I discovered that, not so long ago, in rural areas, they used to set an extra place at the dinner table during every somewhat formal meal, for an unexpected guest, beggar, *survenant* or simply a traveler in search of shelter.[2] There was even a special piece of furniture, called the beggar's bench, reserved for any overnight guest. This goes to show to what extent the other, the stranger, was held in respect. To the point of being mythicized in certain more remote areas. In Germaine Guèvremont's *Le Survenant* – a realist novel set in the Chenal du Moine in the Sorel Islands – the newcomer is called *le Grand Dieu des routes* – the Great Lord of the Open Road.

Even allowing for a measure of fictional romanticism, there's still that ambivalence in it, between the attraction of a nomadic existence, like that of the *coureurs des bois*[3] of bygone days and the sedentary necessity of farmers, of the *habitants*.[4] I even wonder if every *Québécois* – and every *Québécoise* – doesn't secretly wish to live like François

Paradis, the legendary hero of *Maria Chapdelaine,* who must resign himself to tilling the soil like Eutrope Gagnon.

Why all the country references? It's just that urban culture, mostly Montréal's, is still too young to have nourished an *imaginaire* and altered behaviours. In most pre-Seventies' novels, from Gabrielle Roy's *The Tin Flute* to Jacques Renaud's *Broke City* and even in some of Victor-Lévy Beaulieu's works, the city signifies alienation, violence, dispossession.[5] Parallel to this hostile space, an idealized countryside consistently sustains characters' dreams. In Réjean Ducharme's *Wild to Mild,* a young couple daily shares the joy of reading to one another from the good book, *La Flore laurentienne,* in between proofreading galleys and massive absorptions of TV messages.[6] Mediated by the book, nature is thus directly associated with a culture it has never ceased to symbolize. Even in a more recent work like Michel Tremblay's *The Fat Woman Next Door Is Pregnant,*[7] a novel spurred by urban impulses, the only real festivities occur when an uncle from the country resurrects the atmosphere of the *veillées de conte* – storytelling evenings – and starts retelling *la chasse-galerie.*[8] Representations of Montréal exempt of negativism or nostalgia for the country are new and relatively rare. They appear in Yves Beauchemin's *The Alley Cat* and in some works by poet-novelists – Nicole Brossard, Yolande Villemaire, Claude Beausoleil and others who partake of modernism. Up until now, such representations were found only in novels that are certainly interesting but have been neither widely read nor discussed and so marginalized, like those written by Jean-Jules Richard or by Jean Basile.

In the petit bourgeois milieux I frequented, a world I could compare to that of Tremblay's characters had they made it in life, people were trying their best to adapt the community and festive habits of rural life to a different context. The first generation to have moved to the city, they have kept many of their ancestors' culinary secrets, and rediscover them mainly for

large family gatherings like the ones to which I was invited. I was thus able to sample *tourtières* and *cipailles, ragoût de porc* and stuffed turkey, sugar pie and *tarte à la ferlouche,* not to mention the hundred and one varieties of homemade cakes that make up the compulsory arsenal of Holiday Season get-togethers.[9] I was made to taste every one of these dishes, each one more delicious than the next, the only drawback being that they're a trifle heavy for our city-cousin stomachs.

But that's the end of the 'heritage' aspect of these evenings, where I met fragmented, de-nuclearized families who, more often than not, now have in common only the memory of joyous reunions with their villager parents or grandparents. Sitting between two chairs, my friends' parents didn't quite know what face to put on for the young foreigner they so generously invited. Still too close to their rural roots to have surrendered to the infatuation the younger ones – those who are 30 and 40 today – have for antique furniture and a periodical return to the land, but not yet sufficiently adapted to the city to create their own environments, they are like those transparent screens onto which any mildly opaque silhouette fluttering behind them imprints itself. Their dualism has taken the shape of a double refusal: rejection of a civilization they've succeeded in escaping, yet malaise in the face of a certain urban rhythm with which they feel out of synch. In their eyes, Montréal remains enigmatic, the 'city for others.' I left these meals saddened, and looking forward to the unequivocal simplicity of our great student potluck suppers.

I've started spending time in the city's literary circles as well. My friends have all had some part to play, large or small, in various cultural journals which, in Québec, are stunningly diverse. This is where aspiring writers get their first break, where the better-known ones publish fragments of works-in-progress, and where, generally speaking, literary, artistic and political current events are commented on and criticized. I admire the very classical sobriety of a theatre review like *Jeu,*

the spare beauty of *Estuaire, Parachute*'s form/meaning, *Spirale*'s sense of provocation, the thematic issues of *La Nouvelle Barre du Jour,* and the new lyricism of *Les Herbes rouges.* But I derive particular pleasure from reading the less specialized reviews, like *Dérives, Liberté* or *Possibles,* which cover the whole range of current events and have no qualms about addressing any topic under the sun – or just about – with varying degrees of impertinence.... For criticism still largely wins out over essays – and the political question, while always implicitly present, is rarely dealt with head on. *Québécois-es* writers seem to have opted either for a sulky silence on the subject, or for a relentless demonstration of the mistakes made by the provincial politicians in whom they had put all their hopes and faith. It doesn't take long to realize that they've chosen the civility of drawing-room conversations, the academism of university discourse, or schoolyard naughtiness. Will they have sufficient resources to outgrow the sort of negative consensus slowly settling into their society and into their prose? All told, I'm fed up with the current wailing wall, made from misshapen pieces of the Parti Québécois. Please let's talk about something else! And about some*thing* too. For there exists a form of pretention I will never subscribe to, which says that writing, and therefore language, is pure form devoid of any ideological content.

On the other hand, I like the relaxed atmosphere among the writers and aspiring writers I'm getting to know. Most of them know each other, have a few nasty words to say behind each others' backs, but put up with one another rather well. And make the most of any opportunity to get together. I've spent some very pleasant moments in their company.

Looking forward to hearing from you,
Roxane

Translator's Notes

1. *imaginaire*: the French adjective 'imaginary' used as a noun. Not the same as imagination, it has the idea of territory, an inner landscape of possibilities. Barthes' translator Richard Miller translates it as 'image-reservoirs,' while in *New French Feminisms*, Yvonne Rochette-Ozzello renders it as 'imaginary order.'

2. *survenant*: from the verb *survenir*, to appear suddenly. Germaine Guèvremont, *Le Survenant* (Montréal: Fides, 1977). (First published in 1945.) *The Outlander*, translated by Eric Sutton (Toronto: McGraw-Hill, 1950).

3. *coureurs des bois*: literally, woods-runners. Describes the hunter-trapper-adventurers in seventeenth-century New France who traded furs with the Indians and adopted their language and way of life. The term later became pejorative when the *coureurs des bois* were accused of introducing Indians to 'firewater' and of generally doing violence to male and female Natives. The *coureur des bois* is a legendary figure in Québec literature.

4. *habitants*: settlers, people living on the land.

5. Gabrielle Roy, *Bonheur d'occasion* (Montréal: Stanké, 1978). (First published in 1945.) *The Tin Flute*, translated by Hannah Josephson (Toronto: McClelland and Stewart, 1967).
 Jacques Renaud, *Le Cassé* (Montréal: Parti Pris, 1964). *Broke City*, translated by David Homel (Montréal: Guernica, 1984).

6. *La Flore laurentienne*: classic book on the flora of Québec, written by Brother Marie-Victorin (1885-1944). See reference to the same Ducharme novel, First Letter, note 2.

7. Michel Tremblay, *La Grosse Femme d'à côté est enceinte* (Montréal: Leméac, 1978). *The Fat Woman Next Door Is Pregnant*, translated by Sheila Fischman (Vancouver: Talonbooks, 1981).

8. *la chasse-galerie*: internationally known folktale about a group of people who, having made a pact with the Devil, are flown through the air at night, at top speed in a birchbark canoe towards the destination of their choice. Imported to New France, it came to symbolize the dream of those who, lost in the immensity of a country without roads, would like to find themselves magically among their family or back in civilization. For example, a lumberjack in a snowbound logging camp might bargain with the Devil to spend New Year's with his sweetheart or family, on the condition he not swear, nor touch the crosses on steeples, as he speeds by aboard the flying canoe. If he does not comply, the Devil takes his soul.

9. *tourtières*: deep-dish ground meat pies.

cipailles or *cipâtes* (from *six pâtes*, six layered-pie): deep-dish pie made of potatoes and various kinds of domestic and game meat.

ragoût de porc: pig's feet stew.

tarte à la ferlouche: pie filling made from molasses, maple or brown sugar, often with raisins.

FIFTH LETTER

April

Vancouver bound! The pretext: to gather information about the newly-formed International Canadian Studies Association, which is holding its first conference. The real reason: to dip my toes in the Pacific Ocean and, if only symbolically, to cross the huge expanse of this country. A five-hour flight separates Montréal from the West coast: two hours less than from Paris. Still, I left Montréal with the impression I wasn't going very far, brainwashed by federal propaganda which says the Rockies and British Columbia are part of the inner landscape of any Montrealer or *Québécois-e*. Isn't this the best proof of how well I've adapted? This tourist policy has even succeeded in convincing some *indépendantistes* that they would never recover from the trauma of possibly losing these mountains, even though they are unknown entities to most of them. So I went off in search of 'Great Canada.'[1]

The plane was jam-packed. Along with the businessmen, visibly bored with this kind of trip, are the noisier students, academics, and journalists invited to participate in one of the concurrently-held ICSA sessions. The flight attendants seem puzzled. As one welcomes passengers on board, she attempts a curious kind of mental gymnastics for a while, trying to guess which language each person speaks based on how they look or what they're wearing, greeting the bearded men in French and the others in English. Then, put off by the skeptical looks she is getting from some men, and especially from some women, she chooses to address the passengers in English only. For a moment I become convinced of the crew's Anglophone unanimity, until I realize that a funny sort of bilingualism has been established aboard this aircraft. The flight attendants (women all) speak French among themselves

55

and English to the public. (Unless passengers put up particular resistance.) Nonetheless, I do manage to order tea in French. A message in this same language informs me that the weather is just as bad in Vancouver as in the rainy Montréal I've just left. The voice thanks me '*d'avoir voyagé Air Canada*.' Those are the last words of French I'll hear in public places for the rest of my trip.

I'm immediately struck by the beauty of the city, probably one of the most successful urban developments in North America. An astounding feat reminding me of nineteenth-century French writer Alphonse Allais' remark to the effect that cities should be built in the country, where the air is cleaner! Vancouver looks like an urban resort area combining the advantages of mountain and ocean. Its jealously preserved coast stretches into huge beaches cared for with a gardener's touch and, in the summertime, its many marinas attract boating and windsurfing enthusiasts. Forest-lovers can choose to explore the footpaths in Stanley Park or to wander like fairytale heroes and heroines, among the giant tree trunks of neighbouring mountains. At first glance, everything here is *calme, luxe* and perhaps – but nothing is less certain, for the relics of British occupation are rather silent on this point – *volupté*.[2] Downtown highrises, some of which were designed by Erickson, the famous architect, convey a spare and elegant modernism, their concept having been inspired by the luxuriance of curtains of greenery or murals of water.

Discretion is of the essence in this place once inhabited by the most Royalist of Anglophone immigrants and now taken over by people of various ethnic origins whose attitudes have been modeled on that of its first occupants. The Italians have retained their elegance but have become untalkative. Only the Chinese and Japanese, even when they're second- or third-generation Canadians, resist assimilation. In fact, they're the only ones you don't see along the shores of English Bay,

indulging in the systematic asceticism of jogging, which consists of sweating every drop of liquid out of your body at least once a day in order to feel like an efficient worker and a contented human being.

I'm writing this letter from one of these typically British English Bay hotels, ivy-covered outside and oak-paneled inside, a seaside hotel where, like most places in Vancouver, every effort is made to find the shadiest spot for the tables. So that most of this city's cafés and restaurants resemble basements in suburban Montréal homes or the *bars-salons* in *Québécois* villages.[3] Except that out West, the intensity of the lighting is inversely proportional to the size of your bill. I can presently see just well enough to tell you about my trip to that haven of tranquility that is the University of British Columbia. That's where the colloquium was being held.

In this institution, say malicious tongues, the gardeners' total wages almost equal the professors'. So there's no need for me to insist on the variety, the beauty and the arrangement of its green spaces. Yet it was in this Edenic village, where libraries and nude beaches artfully blend, and in this atmosphere of extreme gentility, that I understood the insidious violence perpetrated on the *Québécois* people. A day in the life of this colloquium, with its Canadian and international calling, will tell you more about the subject than any other explanation.

First, some preliminary details: the advance programmes sent out were in English only, so I wrote a letter of protest saying that I was an 'internationalist' for whom Canadian Studies had nothing to do with that language. So it was me, a newcomer to this country, who was forced to call this Ontario-born organization to order by asking them to respect – which seemed to me a minimum of common decency – the official law on bilingualism! They said the were 'deeply sorry' and sent me a French-language version of the programme.[4]

On the whole the colloquium was what I'd expected. In the morning, three English-Canadian stars spoke, including the author of a new report on federal cultural policy, a man named Louis Applebaum. A well-known Montréal journalist was supposed to present the combined opinions of a woman, a *Québécoise* and a person interested in culture all rolled into one. She chose to speak mostly in English, even though a large part of the audience said they understood French. In so doing, and thanks to some well-chosen words, she even got a laugh out of this Mr. Applebaum who, a few minutes earlier, had flippantly announced that *Québécois-es* would disagree with his point of view.

Very little time had been set aside for discussion: one of the afternoon speakers said she would challenge the report, especially in regards to its 'oversight' of Québec culture and literature. Mr. Applebaum told her it was the provinces' responsibility to deal with provincial culture. A male participant from Yugoslavia then remarked on the role of the 'token French-Canadian woman' played by the female participant in the panel discussion.[5] There, no doubt about it, was an illustration of the proposed federal model.

This was the first act in a ceremony whose second act was even more 'typical.' Towards the end of the afternoon, in front of a nearly empty room, two Montréal academics addressed the issue of nationalism in the arts and in literature. English-Canadian participants started leaving the room in droves as soon as they heard a word of French. As for Mr. Applebaum, he just happened to leave moments before the woman who that morning had said she would challenge his report, gave her presentation.

Many Québec intellectuals and artists choose to refrain from participating in farces of this nature. Others smilingly take the opportunity to shake some hands and believe that all is well in the best of all possible worlds. Some seem to derive personal satisfaction out of it, deeming themselves Québec's

brightest lights because they are the only ones invited. While others still go on thinking, in vain, that their presence will help change the situation. Sooner or later they become aware of their role as extras in a ritual whose order escapes them. The very fact that they protest serves to sanction those who mask their indifference behind a sort of strategic deference. Everyone awaits their little protest number and once it's over, they are gently made fun of behind the scenes, with the complicity of some better-assimilated Francophones who thrive in this kind of organization. With a few exceptions, Québec is ignored in English Canada. Except when things are going badly, when there are bombs and terrorism, or when a Prime Minister must act like a dictator to solve his government's problems. Then, gleefully rubbing their hands together, they say, 'oh, those *Québécois-es*, they're so crazy!'

During the afternoon session, the Québec lectures were particularly well-received by the meagre audience still present in the room. I learned a lot. For example, that between 1920 and 1930, regionalism in 'Canadian' art was exclusively linked to the landscape and to the representation of wide-open spaces, while during the same period, a similar concern for rootedness led *Québécois* painters to choose figurative representations of villages quietly nestling on mountainsides.[6] It seems that the English-Canadian claim to specificity, in painting anyway, was for a long time limited to an affirmation of territory. I'd like to investigate this further, as well as the question of the modernism of cities and factories put forward by some Québec artists who were contemporaries of the '*terroiristes*.'[7]

In another field of interest closer to my own, the lecturer spoke on a topic which has become a kind of taboo in the best intellectual or artistic Québec society, that is: the relationship between literature and nationalism. She started by outlining the contradiction between the two terms, their very incompatibility, and went on to declare that in times of crisis, their

conflation becomes inevitable. She spoke about the legitimation crisis that Québec literature experienced during the nineteenth century and the first half of the twentieth century, about the political crisis it went through in the Sixties, and about the crisis in political involvement now occurring. She concluded that *Québécois* literature had gone from being a nationalist literature to a national literature, recognized as such inside as well as outside Québec. She also speculated as to whether this literature wasn't being subjected presently to the guillotine of a latter-day Durham report, under the guise of generosity and liberalism. She was referring to the English lord who, in his now-famous (or infamous) text of 1839, accused *les Québécois-es* – then designated by the term 'Canadians' – of being a people 'without history and without literature.'[8] The new report on federal cultural policy, the Applebaum-Hébert report, has simply neglected to mention the existence of a distinct Québec culture and literature. It cleverly couples the more politically commited *Québécois-es* writers with their Anglophone colleagues, associating them in spite of themselves with the fiction of 'one' Canadian culture and 'one' Canadian literature. 'Everything happens as if Québec had already ceased to exist,' wrote François Ricard in the journal *Liberté*.

That, in short, is what I learned from this polemical and well documented lecture which was, as is often the case with these events, preaching to the converted, given the fact that the others, and notably the principal actor being challenged, had left the premises. I then became aware of the thickness of the wall separating *Québécois* anxiety from 'Canadian' triumphalism.[9]

The third act of the play was yet to come. When it did, it looked like the end of a bad comedy. A banquet given by a private company, a subsidiary of Bell Canada, rewarded conference-goers by offering them, in lieu of a bilingual menu, the translation of 'Welcome' by 'Bénédicité.' The food

was good. After three words in French, endless speeches in English congratulated the prize winner – an Englishman who'd emigrated to the United States after teaching at the Royal Military College in Kingston, Ontario – for his interest in Canadian Studies. Out of one hundred people attending this banquet, five or six were from Québec. Some reacted quite strongly to this non-respect, by a Canadian organization, of a minimal amount of bilingualism. Others said they weren't surprised, that they'd come to expect such things. We then learned that the next president of the Association would be one of the five or six Francophones present: the very one who had left Québec years ago. I realized how closely associations of this kind, be they academic or cultural – in either case generously funded, it's true – mimic the moves of the political game. To maintain the illusion of a country where minorities can freely express themselves, these organizations will, along with State bodies involved with culture, give preference to a Manitoba Francophone or a Québec Anglophone. For the dominant powers, this cross-perspective has the advantage of marginalizing Québec representation even more by reducing it to the rank either of a 'Francophone Québec' delegation, or to that of a Francophone minority with the same status as Canada's other ethnic groups. Which boils down to treating Québec like an island among other islands, only just a little more bothersome, but not special or specific enough to warrant a place of its own.

You might think I'm making a hasty generalization based on an experience which may after all have been merely tactics on the part of blundering organizers. The *Québécois-es* present assured me that this was not the case. Most of them seem exasperated from struggling and protesting against a situation which they've apparently lost all hope of changing. Some even admitted very candidly that they are none the worse for wear. The evening ended quietly. In among the tables, people were heard muttering that some attempt should

at least have been made to have a speech in French. One of those in charge replied that he'd had nothing to do with it, but that 'from now on,' things would be different.

I don't like colloquia much. A single day of this one was enough for me. The following day I visited the jewel in the crown of UBC, its Museum of Anthropology. In a building brilliantly designed by the architect Erickson to let in the light and emphasize the gigantism of the totem sculptures, you can admire the magnificent past of Haida and Tsimshian Indian civilizations. These Canadian West Coast civilizations display affinities with the luxuriance of Polynesian art, where function was inconceivable without aesthetic concern, indeed without mythical resonance. I can't begin to describe to you these marvels of refinement and balance that – from the beams of a house to the more or less elaborate masks, from a simple carved-out bowl to dugouts, not to mention the whole assortment of rattles, plates, jewellery and ornate chests, – illustrate the variety and intricacy of this art which is as astonishing for its large-scale accomplishments as for its miniatures. Also, I can't begin to tell you how disturbed I was at the end of the afternoon when, in a museum whose glass walls are perfectly integrated with the landscape, it occurred to me that the interest whites presently show for aboriginal civilizations coincides with the very moment of their decimation. Something from that federal report I mentioned earlier kept coming back to me, the sentence asking that 'very special' attention be given to Indian and Inuit cultures. I predict that a hundred years from now, another report will suggest that the same special attention be granted Québec culture. This seems to me quite in keeping with the logic of the current rationalization. It won't be the first time, in North America, that liberalism has been used to level out and neutralize. Now I understand the statement made by Philippe de St. Robert, an ex-journalist from *le Monde* who said that 'Canada's Anglophones only recognize their violence once they've reaped its harvest.'

Yet it is from an English-Canadian writer that I'm borrowing the phrase which best sums up my impressions of this trip, to the effect that this so-called bilingual country is also a 'bi-zarre country.'

Take good care,
Roxane

Translator's Notes

1. 'Great Canada': in English in the text.

2. *luxe, calme et volupté*: a much-cited line from 'L'Invitation au voyage,' a poem from *Les Fleurs du mal* by French writer Charles Baudelaire (1821-1867). Translated as 'order, luxury and voluptuousness' by Edna St.Vincent Millay and George Dillon in *The Flowers of Evil* (London and New York: Harper Bros., 1936); see 'Invitation to the Voyage.'

3. *bars-salons*: Québécois bars with tables and a dance floor, where there's often live music – usually C&W, in French!

4. 'deeply sorry': in English in the text.

5. 'token French-Canadian woman': in English in the text.

6. 'Canadian'/landscape: both in English in the text.

7. *terroiristes*: from *terroir*, soil, local; a pictoral genre referring to art that is inspired from the artists' closeness to the land, regionalism.

8. Lord Durham (1792-1840) was Canada's twelfth British governor. His history-making 'Report' recommended abolishing the constitution and anglicizing French Canadians.

9. 'Canadian': in English in the text.

SIXTH LETTER

May

Back in Montréal, newspaper headlines inform me that Québec Anglophones have formed an association – Alliance Quebec – to challenge the validity of decrees written in French only and, by the same token, the legitimacy of Bill 101 making French the official language of Québec. The Anglos speak high and mighty and are easily moved to protest. They'll agree with a French Québec if they can live here in English only. They don't take well to their change of status from dominant minority to plain and simple minority. Not satisfied with having been the most privileged minority group in any Canadian province up to now, most notably through the school system and its funding, they're now using the federal law on bilingualism to accuse *les Québécois-es* of intolerance. Yet Bill 101 preserves acquired rights and allows for a double educational network. It does specify, however, that newly arrived immigrants whose mother tongue is not English must attend French schools. It declares French the language to be used in the workplace, in communication, as well as on public signs. Meaning that Miss Patate and other hot-dog stands along the highways, such as Ti-Jean Snack Bar must now be francized: they will, as a matter of principle, become Mademoiselle Patate or Comptoir Ti-Jean. This is the zany side of a situation which isn't funny at all.

I'm still amazed that something so necessary has created such an uproar. The French language is losing ground in North America and is in danger, sooner or later, of becoming just a label. There's no sense in even mentioning Louisiana where, as documentaries reveal, only a handful of Cajun descendants are still able to hum a few French folksongs. Nor will the aristocratic Francophile *salons* or groups of French culture lovers in New York or San Francisco have much

impact on the situation. Even in Canada, an officially bilingual country, French-speaking minorities outside Québec which were still quite large some thirty years ago are now steadily decreasing in numbers. After a trip to Manitoba, a journalist recently concluded that French has approximately one generation left to go, because the young people under twenty-one are refusing to take up their elders' struggle for an idiom which, in their eyes, represents more of a handicap than anything else. Who can blame them? When a language is no longer useful it becomes suitable only for kitchens and traditions. And these are in no way the cornerstones of America. As for *l'Acadie,* it has witnessed the exodus of its Francophone population. A woman friend told me that in Moncton, English is just about the only language heard in public places now. Many creative people have emigrated. In fact, hasn't Antonine Maillet herself chosen to live and write in Québec?[1] True, other artists do stay to live, create and die in *Acadie.* I admire their courage and tenacity. In my opinion, only a strong Québec will be able to give weight to claims threatened by the status quo or back-to-the-land regression.

Even the latest Statistics Canada figures (official document, April 26, 1983) show that English is presently exerting a greater power of assimilation in 1981 than it did in 1971, and this is true outside as well as inside Québec. I'll spare you the charts mapping these linguistic transfers. One can only come to the conclusion that despite its bilingual façade, the current federal government is totally inept at ensuring the future of French -speaking groups in Canada. My own experience has provided me with ample proof that outside the federal Civil Service – where I was nonetheless told, in confidence, that English is still the language of internal communication everywhere but in the Québec offices (and especially in Ottawa, the capital) – there is no point in addressing anyone in the language of Racine, Duras and Miron.[2] I found out that in government bodies, even exemplary ones such as the Canada

Council, a Francophone writing a memo or a report in French will be asked to translate it, whereas the reverse simply does not occur. The more they work in English, the more the *Québécois-es* who've emigrated to other provinces end up regarding French as a disembodied idiom. I remember a Montrealer I met in a 'California-style' Mexican restaurant in Vancouver.[3] He confessed he couldn't serve us in French, as he'd never had the chance to translate his menus. I also remember a *Québécoise* living in Toronto who had decided to take her children out of French school because she didn't want to reinforce their isolation and marginality. I'd have done the same.

Conversely, when an Anglophone colleague of mine, a very pleasant woman, swears to me that she is in no way responsible for the whole Conquest story, and assures me that she is very happy to socialize with *Québécois-es* as long as she can read English on all public buildings – a point of view she defends with fierce determination – I feel like telling her to *Give me a break!* Which scandalizes the *Québécois* people involved in the discussion, whose greatest fear is of hurting her feelings and being taken for narrow-minded 'frogs,' and who are more than fed-up with this bothersome language issue.

[...]

So the *indépendantiste* government of Québec began by ruling on language and made a move that some consider an insult to reason: it declared that there would be a small French-speaking territory in North America. That the rest of the entire continent, with a few exceptions here and there, is unilingual Anglophone, everyone seems to consider this as normal. But that a minute part of it might be unilingual French stirs up tidal waves of emotion. My God, but monotony is powerful when it wears the name of empire! Isn't Switzerland, in spite of and because of its trilingualism, divided into regions where one or the other of its three languages domi-

nates? In reality, Québec was and still is, to an extent, the only Canadian province where bilingualism is actually put into practice. I can personally attest to this because as soon as people realize I'm a foreigner, they tend to address me in English first: otherness, here, is immediately associated with the neighbour's language.

If only it were limited to tourism, this use of English would wreak very little havoc. I've no quarrel with *les Québécois-es* being bilingual, tri- or quadri-lingual, since I myself like nothing better than to blather on in several languages. That's not the problem. It has been shown that when the daily use of bilingualism is imposed on a given community, this leads either to assimilation, which is the extreme limit of the devaluation of a language, or to aphasia. 'I've always heard it said,' writes Brecht in his *Refugee Dialogues* about some place or other I can't recall, 'that the local people are very close-mouthed. Given that it is a mixed and bilingual population, one could say these people are silent in both languages.'[4] Writers here had become aware of this threat much sooner than governments and politicians and in order to denounce it, borrowed a bastardized language contaminated with English, the popular Montréal parlance known as *joual*.[5] Transformed by writing, this language became lyrical, as beautiful as the blues Black Americans sang in counterpoint to their alienation. But everyday expressions were not so eloquent: *'Je m'en vas à la grocerie...pitche-moi la balle...toé, scram d'icitte...i t'en runne un coup.'* ('Aliénation délirante' in Gaston Miron's *L'Homme rapaillé*).[6] Was it the power of denunciation or the fact that the situation had become so alarming, that explains the creation within the space of a few years of a *Régie de la langue française* in Québec, and of a *Conseil de la langue* (language board) responsible for the application of Bill 101? To my knowledge, this is the only place on earth where it is necessary to police and protect everyone's way of speaking like this. The obsessive recurrence of this issue is

indicative of the scope of the problem. While it is difficult to believe in the magical properties of a legislated bill, it is even more naïve, I think, to claim that very high stakes are not involved in the development of natural languages.

What surprises me most about this territory I've been discovering over the last few months is not the importance given to this issue – a degree of importance which would be considered inordinate anywhere else – but rather the fact that the two side-by-side nationalisms, those of Prime Minister Trudeau and of Premier Lévesque, have such difficulty outgrowing the problem. Trudeau's whole pan-Canadian dream was crystalized in a showy bilingualism designed to impress international circles and visitors just passing through. An updated version of the old French-Canadian messiah complex: as latter-day discoverers of the Rocky Mountains, Canada's Francophones would be invested with the mission of transmitting the graciousness and benefits of the French language to the whole country. A form of rhetoric tantamount to considering language a mere shell, or the shiny cherry atop the multilayered cake of Canadian unity. As a result, part of Québec's electorate rushed headlong into this mirage while Europe delivered a standing ovation. As for our Oriental countries, I suspect they have other fish to fry.

Isn't Trudeau himself a perfect example of the impossibility of what he's proposing? The first time I heard him on the radio, I mistook him for a Westmount intellectual (Westmount being Montréal's well-to-do English residential area) who'd learned French at McGill University. I was later told that he is in fact a French Canadian of bourgeois background, the son of a Francophone father and an Anglophone mother. My curiosity was aroused and I wanted to find out more about him so I read *Grits: An Intimate Portrait of the Liberal Party* by Toronto writer Christina McCall-Newman. In reading I discovered that Canada's PM had studied at Collège Jean-de-Brébeuf, the province's poshest institution for classical education, that he

had later studied in England and had been fascinated by Anglo-Saxon liberalism. His political life had begun with a commitment to *Cité Libre,* a journal published by intellectuals opposing Duplessis, the then-Premier of Québec renowned for his stone-age conservatism.[7] The vision projected by Trudeau of Québec's affirmation is haunted by that figure of a retrograde, vengeful ultra-conservatism. This wealthy aesthete and dilettante has always had nothing but contempt for what he calls *Québécois* people's tribal instinct in the name of an internationalism which was, until just recently, attempting feats of derring-do without even touching upon the concept of nation. By a strange reversal, politics in turn made him the champion of 'Canadian' nationalism, a movement of resistance against Americanism and of indifference to the Québec question.[8] A brief analysis of his speeches is enough for any even slightly attentive listener to realize that everything *Québécois* is looked upon as a tribal remnant while the word 'Canadian' becomes an indisputable sign of internationalism.[9] Such recognition of the other's virtues harkens back to colonial imitation. I'm told this attitude is not uncommon among Francophones who emigrate to Ottawa. The people of Québec had already seen it in action with Wilfrid Laurier and Louis St-Laurent, two other Anglophile Prime Ministers who were content to hand the power over to the Anglo-Saxon majority while flattering their compatriots' vanity. The book *Grits,* which one can hardly suspect of having an *indépendantiste* bias, really opened my eyes: it seems to be part of Québec tradition to elect politicians under false representation.

Yet the Trudeau phenomenon is different from the others. Despite the War Measures' Act and the repatriation of the Constitution without Québec's consent, history may well judge him the most *Québécois* of all the stooge-kings. Because of the law on bilingualism and the sprinkling of Francophones he assigned to certain key positions of power. Throughout his

mandate, the leader of the famous 'French Power' tried, with the diligence of an eager student, to dispossess Québec of the few institutional powers it had been granted.[10] What some called the 'scorched-earth strategy.' As if a new Canada were going to emerge from the ruins of history. The tactics are quite simple: in order to silence Western Canada and create a mythical unity, you sacrifice Québec, turning it into just one among the ten provinces, nothing more, which amounts to denying its specificity. Maybe the Anglophones were right when they criticized Trudeau for his intellectualism: the Canada he was seeking to erect is a view of the mind, a kind of abstraction built solely on the justification of a territory to occupy. Only he forgot to have human beings occupy it. Or let's say that he put himself rather too centre-stage as a model. Himself, i.e., a bilingual person more comfortable in English than in French, ill-received by the Anglos with whom he tried to flirt but who found him too culturally different from themselves, increasingly despised by the Francophones whose singularity (whose culture, therefore) he reduced to a mere factor of language. Trudeau is a walking contradiction hidden behind the mask of a haughty, cold, nasal-voiced man endlessly preoccupied with constituting his public persona and being well regarded by the powerful. Some circles are still willing to grant him the benefit of good faith. The Canada he represents, a nowhere-land, only interests me in Ubuesque theatre or in Surrealist plays.[11] I cannot bring myself to believe in the utopia with which he cloaks his disembodied ideal. To my mind, the future of the Francophones of America lies neither with Trudeau nor with the current federalism. The latter, in claiming to save minorities, has succeeded in protecting only one of them, Québec's Anglophone minority. It was, no doubt, the one most threatened with assimilation . . .

 I'm quite convinced that, were I *Québécoise,* I'd opt if not for independence then at least for one of its variants. I can just see you smiling, Sarah. Yes, me who fled a nationalism made

of intolerance and fanaticism! It took me a while to understand that there is not one but many nationalisms, and that we shouldn't confuse the one's desire for expansion and conquest with the others' more elementary awareness of their dignity compelling them to be seen and heard. Dominant powers have a vested interest in letting those dominated believe that any form of nationalism is fascist at heart. But, tired and resigned to their fate, the *Québécois* people I've been meeting are giving up the fight or taking refuge in the nostalgic memory of their past commitment. Having lost the Referendum battle, they're turning away from the political scene, and no longer believe in the legitimacy of their cause. Scapegoats are everywhere, from René Lévesque to the humble craftsman still enamoured of the furniture he builds. Let one of their own slip up and, like the fabled black sheep, he is immediately considered a pariah, while their opponents get away with the dirtiest deals and elicit no more than a shrug of the shoulders. Many *Québécois-es* are complacently grateful for the poisoned gifts Ottawa hands them on a silver platter while robbing them of their rights. Others, mostly the young, have elected nuclear war as the only terrain for political struggle. Probably as a reaction to the generation preceeding them, and because of a more than commendable planetary consciousness. But isn't it easier to devote yourself to a great cause, however admirable it may be, than to deal with more concrete problems gnawing away at even the most determined energies? As if it were possible, in this as in anything else, to escape Pascal's wager.[12] I'd like to shake them out of their lethargy, accuse them of 'copping-out,' and tell them that not choosing is a choice in itself. Is there no valid and acceptable form of nationalism other than the nationalism of winners? Can't they see that the frenzied individualism they are being offered is the silent but deadly weapon of centralist powers?

This country's political situation reminds me of a *boulevard*

comedy sketch I might call 'The Grand Illusion.'[13] In this setting, Québec is a mistress who long thought she was the legitimate wife. She is courted, flirted with, constantly reassured about her charms, about how much she matters. She is almost family, thanks to longstanding alliances and childhood games. Once, a long time ago, she played with Ottawa, exchanging powers for roles. For a passionate declaration of love she thought she once heard, hadn't she indeed let her heart rule her head and sacrificed the common measures of reason? She let herself be drawn into this affair with the naïvety of a young maiden. Besides, does she have any real grounds for complaint? She is still being treated quite gallantly. She is still being consulted about everything ... except when it comes to her own future. Locked into a kind of timeless present, she must constantly please for fear of being disowned. One day, weary of her showcase role, she asks to take part in the family council. This is where things take a dramatic turn. She is introduced to the gathering of sisters-in-law and encouraged to smile at the young bride, the friend from out West who is already the mother of fine healthy children. The beautiful *Québécoise* mistress doesn't understand anymore. She is told that all of this transpired in the utmost legality and that her pseudo-marriage does not give her the right to be consulted, nor even to disapprove. Outraged, she retreats to what is left of her land and is accused of shrewishness. Ever since, she has regularly received either a brickbat to silence her, or a bouquet to mollify her.

How does one begin to grasp the fact that French Canadians acted as task-masters in the dispossession of their own people? The new Canadian Constitution, hidden under the hat of constitutional repatriation, sanctions the end of any special status or privilege for Québec. Given these conditions, I find it hard to fathom why nationalism has become such a taboo subject here, frowned upon as rank pettiness! You probably think I'm overreacting. It's just that I find the people of

Québec much too tolerant. Their major flaw is believing all the bad things said about them in Ottawa.

I'll close with these words from Québec writer Doctor Jacques Ferron, a very important figure of the Sixties: 'Any way you look at it, Québec is an intellectual difficulty, an entity not found in book definitions. If you attempt a fitting by taking it to one of the great tailors such as Maurras, such as Memmi and Fanon, it comes out looking all wrong.'

Kisses,
Roxane

Translator's Notes

1. Antonine Maillet: internationally renowned best-selling Acadian author and playwright, winner of the Prix Goncourt in 1979 for *Pélagie-la-Charrette* (Montréal: Leméac, 1979). *Pélagie: The Return to a Homeland,* translated by Philip Stratford (Toronto: Doubleday, 1982).

2. Jean Racine, French classical playwright (1639-1699).
 Marguerite Duras, contemporary French writer and filmmaker (1914-).
 Gaston Miron, militant *indépendantiste* poet and editor (1928-).

3. 'California-style': in English in the text.

4. Bertolt Brecht, *The Refugee Dialogues*: translation mine.

5. *joual*: Montreal working-class pronunciation of *cheval,* horse.

6. Roughly: 'I'm goin' to the grocery ... pitch me the ball ... scram outta here, youz ... he can really run' The title *L'Homme rapaillé* – a participle Miron derived from the *Québécois* noun *rapaillage,* something like 'recycled straw' (*paille*), means something like a scarecrow man, one made up of random parts. Marc Plourde edited and translated *L'Homme rapaillé* into an anthology of Miron's work titled *The Agonized Life* (Montréal: Torchy Wharf, 1980).

7. *Cité Libre*: journal founded in 1950 by unionists, writers and academics, among them Pierre Elliot Trudeau.

8. 'Canadian': in English in the text.

9. 'Canadian': in English in the text.

10. 'French Power': in English in the text.

11. Ubuesque: from *Ubu Roi,* an absurdist character appearing in several plays by French writer Alfred Jarry (1873-1907).

12. Pascal: refers to French philosopher Blaise Pascal (1623-1662) and his *argument du pari* to the effect that by wagering on God's existence, non-believers have nothing to lose and everything to gain. It has since taken on a more secular meaning, i.e., that not choosing is a choice in itself.

13. *La Grande Illusion* is the title of a classic 1937 film by French director Jean Renoir.
 Le boulevard is a typically French form of light-comedy play performed in theatres along the Paris boulevards.

SEVENTH LETTER

August

I've rented a house on an island for the summer. I plan to write my thesis here. I needed to get to know rural Québec, the object of so much praise and of so much invective. My French friends envy me for having found a quiet spot not yet overrun by the tourist trade. My Montréal friends think I'm in a state of total regression and that I've given up on the present because, to their minds, the only respectable retreats are the beaches of Maine or Virginia.

I arrived here with a head full of stereotypes, expecting to play the female Robinson Crusoe, or at least to find myself steeped in folklore. My first discovery was a brutal shock. It happened on the night of *la Saint-Jean Baptiste,* Québec's traditional holiday. Last year, in Montréal, I walked around the parks to see the bonfires and the square dancing. This year's *fête* was vastly different. On the east end of the island, called *Pointe de Beaujeu* after one of its first lords (*seigneurs*), a huge bonfire was ablaze on the beach while islanders gathered round a polyethylene tent listening to disco music. Some were dancing. Others were content to drink beer after beer while frantically waving their arms to shoo away the mosquitoes. I confess I was a bit disappointed: this wasn't quite the scene I expected to find in the middle of the St. Lawrence River!

It took me a while to discover the island. A microcosm of *Québécois* life, it could offer passing tourists only the nightmarish vision of its dreary bars and beer cans forgotten along the roadside. You have to go beyond these appearances. Or rather overlook them, shift your angle of vision. I slowly acclimatized to this place of excessive wind and sun, where the humblest gestures of daily life take on the aspect of a ritual.

I fixed up a little corner *au nordet* – a French seamen's expression meaning 'to the north side' of the big house I'm

living in – where I put my worktable so as to see the river at all times. This is where I'm writing you from this morning. It's a bright sunny day. Behind me a woodpecker is aggressively hammering at the bark of a willow tree. In front of me, the water is discretely receding from the shore, making long grassy sandbars appear where, come fall, the bulrushes will become the wild geese's favourite food. You never know where the shore begins or ends, and this imprecision of the coasts imparts a leisurely pace to the day's progress. Lazily stretched out between saltwater and freshwater, this island shamelessly welcomes the sun of Kamouraska as well as the sun of Charlevoix, smoothly moving from one to the other while the gaze follows the tides, choosing to swoop toward the flatland parishes of the south coast or the mountains to the north.[1]

No need to add that everything here takes on a particular relief. Be it the sun, the wind or the rain, each of the elements always asserts itself as though occupying the entire space, completely, forever. When it comes to passions, every gesture, every word is carved out with the declamatory vividness of Easter Island sculptures. Because of the scarcity of possible diversions, beings and things are impressed onto one's memory like the images in a slow-motion film.

Shortly after my arrival I met a wonderful old woman of seventy-five, an ex-city dweller who has retired to this island and is always on the lookout for the latest literary publications. Bright-eyed and nimble-minded, she tells me she prefers books by Henry Miller, Jean d'Ormesson and Marguerite Yourcenar to *Québécois* literature.[2] She even looks like Yourcenar, and like her she bakes her own bread. When I drop by to visit, she invites me in for an aperitif or a cup of tea, depending on the hour of the day, has me listen to rock music, or talks to me about her cushy childhood in the *haute bourgeoisie Québécoise*. She is considering writing her memoirs but has strong doubts about her talent and seems very con-

cerned about what people will think of her book, should she get it done. She spends little time with the island folk, having quickly understood that she would never quite shake off her outsider's status.

For the islanders, the world is divided in two: those who were born on the island and those born elsewhere, the latter being assigned a place on a sliding scale of outsiderness based on their seniority as settlers here, on whether they are landowners or not, or also, an acceptable letter of credit, whether they are related to a local family. But the decisive standard remains the ability to winter over. Only the outsiders who spend winter here, when the island is cut off from just about all contact with the mainland, connected only by a plane bringing basic necessities and ensuring minimal passenger transportation, can dare, after a few seasons, to include themselves among the 'island folk.' And even then . . . In this place where distractions are few and far between, the tourist, provided he or she isn't too arrogant, is nonetheless warmly welcomed and benefits from authentic curiosity combined with an exemplary courtesy.

Those who, like myself, come for a brief stay, have much to learn. Summer is spent preparing for winter and winter spent dreaming of summer. The islanders are very proud of their resources and know how to make the most of them. I've started imitating them: I'm putting up my own strawberry preserves and doing the garden chores vital to the vegetarian portion of my diet. I now know that due to the river's proximity, I needn't fear early or late frosts. I also learned the thousand and one uses of a slightly salty locally-made cheese which surely makes the best *au gratin* dishes ever. Yesterday a young woman revealed ancient culinary secrets to me. Now all I need to do is declare myself a farmer! It could happen, you never know! Believe it or not, when I see three or four horned beasts standing on the hillside, outlined against the setting sun with, in the background, the silhouette of Cap

Tourmente, I must confess I find it all quite picturesque. The scene even reminds me of some Magritte paintings. Mutatis mutandis, of course!

Every day brings its own discoveries. I regularly take walks along a small beach sandwiched between two cliffs, at the place called *Les Jetées* (the jetties), where I enjoy watching the luminous arabesques of the terns, the synchronized dives of the blue herons, or the gay halts of the southbound sandpipers. As fall approaches, I feel the islanders' growing restlessness as they await the ducks, teals, bustards and wild geese who are familiar denizens of this place. A veritable mythology of the hunt has evolved here which is just as palpable, if not more so, in the words that precede the prescribed event than in the gestures accompanying it.

I'm fascinated by the relative self-sufficiency of the residents of this island. Only luxury products are imported. On the other hand, the cheese industry guarantees the export business necessary to agricultural production, which is highly mechanized. There is no government in this place where, contrary to utopian geometries, marginality is more than tolerated. No 'foreign' parish priest has, to date, had enough authority to thwart the homosexuality, in-breeding and polygamy. Back when dancing was prohibited in every parish in Québec, I'm told it's here on the island that people of all sorts came to waltz. Despite all this, the place is peopled mostly with respectable, charitable families! The only law that matters in these parts is the law of survival and the reaching out to help others that this implies. When someone is 'in need,' help is immediately offered.

But between that and proposing this traditional model as a norm, there is a great leap I'm not about to make. I do however admire the freedom I see around me, which is born of autonomy. I also realize, as I get to know the people, that their way of life is not as second-hand as an initial hasty judgement first led me to believe on Saint Jean Baptiste night. If entertain-

ment has, to an extent, become standardized and *kétaine* (kitschy) as it follows the lead of cheap fads propelled by an encroaching consumer society, everything connected to necessity is still reliant on patiently acquired knowledge and a remarkably functional ecosystem.

No, I didn't find the folkloric island I'd imagined. Only an ancient storyteller, bent over with age, seemed to know the repertoire of folktales and legends I was interested in for my research. He told me about the church-building devil, about the little headless man and about the ghosts haunting a manorhouse because Protestant lords had lived there too long. I soon gave up on pursuing my project – a comparative study of nineteenth-century literary tales (*contes littéraires*) and contemporary popular stories – having understood that what is generally designated as the oral tradition has mostly become the realm of university archives. Or, at any rate, it has in highly industrialized countries, where the global village bears increasing resemblance to the one created by the electronic media.

Yet I noticed that the residents of this island have a way with, and an innate need for, words. Everywhere the opportunity presents itself, be it at the general store or on the dock, they gather to make small talk, thus perpetuating a tradition of news-mongering which is as old as the world. The parents' generation expresses itself in a clear high voice, with a surprising precision of vocabulary sprinkled with local particularities. The children have more difficulty making themselves understood. They desperately seem to want to utter a whole sentence in just one breath. Will they inherit the loquaciousness and verbal imagination that allowed Pierre Perreault to make entire films around the islanders' way with language? More skilled at thinking about the future than about the good old days, they voice their dreams from day to day. For them an aurora borealis becomes a familiar *barre à Réal*.[3]

They must see me as the strangest of strangers. Not only

81

because of my distant origins, but because I work mostly 'in books.' An activity that is well-respected if not well-understood. Women here are generally more educated than the men. One out of two women, I believe, has been a school teacher; this antecedent gives her the upper hand where correspondence and accounting are involved. But what's the use, they secretly wonder, of the long hours I spend reading and writing?

[...]

Early *Québécois* literature captivates me with its underlying contradictions, its clericalism, so flaunted, so obvious, the better to conceal all sorts of transgressions. Several of the folktales I'm studying were inspired by legends. The recurring themes and motifs are dominated by devil stories in which a character who has either defied or ignored religious precepts is brought back into the fold after some exemplary punishment, some rigorous deprivation. But too quickly reducing these texts to an appropriation of literature by the nineteenth century's triumphant ultramontanism would fail to take into account a very real complexity.[4] In every case, the sin is presented with the attractiveness and prestige of desire, one all the more violent because it is forbidden. And in most cases, in fact, the hero agrees to the transgression and the writer-storyteller makes this the very subject of his narrative. Lumberjacks selling their souls to the devil in exchange for spending New Year's Eve with their lady loves, Rose Latulippe allowing herself to be seduced by her dashing *cavalier,* and bright-eyed young lads more concerned with chasing skirts than saying prayers taking the risk of being changed into werewolves. The narrative pact also varies from one author to another. Fréchette (*Contes* I et II) is more ironic and playful, more of a free-thinker than his fellow writers. He takes pleasure in demystifying the supernatural and in presenting as his central character a man named Jos Violon, who is an unrepentant storyteller and witness to a popular culture with which he

maintains a knowing complicity. Beaugrand (*La Chasse-galerie*) is closer to myth and to archetypal figures of the imagination while Lemay (*Contes vrais*) is at once more literary, more digressive and moralizing. His stories cover a particularly significant variety of subjects (historical, legendary or quotidian). Others, like those by J.C. Taché or Faucher de Saint-Maurice, are more documentary or inspirational.

So that's where things stand with my research right now, in this place where I feel in such harmony with the scenery that everything becomes easier. Little by little, I'm discovering a dimension of resistance in this early *Québécois* literature which we usually associate with more recent texts. I'm also realizing that the short tale, because of a certain fixedness or permanence of its elements, paradoxically lends itself to multiple variations and reveals the literary profile of an era perhaps even better than do the longer stories. If, as I tend to think, every tale is a *chasse-galerie,* the adventure is all the more challenging because it transports me to an *ailleurs-ici* (elsewhere-here) made up of the countless reminders of experience, of daily life and, inevitably, of culture.[5] To a certain extent, some novelistic mythologies, those of Tremblay, Beauchemin, Poulin, Caron and others, seem to me like artful transpositions.

I took great pleasure recently in reading *Les Grandes Marées* by Jacques Poulin.[6] It's a novel/tale about a translator of cartoon strips nicknamed T.D.B., or Teddy Bear, alone on an island in the St. Lawrence River, whose only link to civilization is a patron who regularly comes to visit by helicopter. Teddy Bear has made up a schedule allowing him to work on his translations and still enjoy some carefully programmed entertainment. All is well until said patron, fearing his protégé will suffer from loneliness, occasionally brings him, along with the usual basket of groceries, a male or a female companion. And so, slowly but surely, human society is reconstituted. One day a counselor of sorts is scheduled to come to organize every-

body. Teddy Bear then swims away from the island towards another one . . .

I keep expecting to run into him on the island where I've taken refuge. Despite the 'on hold' life I led for a few weeks, I didn't miss the presence of Friday, neither Defoe's nor Tournier's.[7] But, like Suzanne on her island in the Pacific, I did wish for the arrival of a companion.[8] I know my Montréal friends couldn't deal with such isolation. I also know I'll be just as happy to say 'Hello' again to the city streets and to get lost in the anonymity as I am presently to live according to the tides, with the river as my sole reference. My tastes are eclectic and I enjoy intermissions.

Should I apologize for it? Sometimes I think Québec's little *intello*-creative bourgeoisie is neatly divided into two clans, not on the question of independence – where you encounter only variations in degree or intensity – but on the love/ *appartenance* to the city or to the country.[9] The line is drawn between diehard fans of Montréal/New York/Ogunquit and fans of Montréal/Québec/Les Eboulements, with a detour via Paris.[10] It reminds me of a hockey game where the two opposing teams play at two different rinks. The challenge being to qualify for the major league. The problem stems from the fact that no referee has been formally designated to select the winners, so each team attributes points to itself depending on its whims, ambitions or arrogance.

While awaiting the outcome, and before the wild geese come flying in over these shores like snowflakes, a kildir plover, heir to three centuries of *Québécois* insularity, asks that I send you its best regards.

Roxane

Translator's Notes

1. Kamouraska: Québec county situated on the south shore of the St. Lawrence River, immortalized by Anne Hébert's novel of the same name. Charlevoix: picturesque county on the north shore of the St. Lawrence River in the Saguenay region, very popular with tourists and a landmark in Québec culture.

2. Jean d'Ormesson: French writer, member of *l'Académie française* and virulent anti-feminist.
 Marguerite Yourcenar: French writer (1903-1987), first woman member of *l'Académie française*, which was founded in 1634.

3. *barre à Réal*: wordplay founded on the sonorities of *aurore boréale*: *barre*, such as the bar of light at daybreak, and *Réal*, a male first name.

4. Ultramontanism: literally, that which stands beyond the mountains, i.e., the Alps, in relation to France; doctrine of those supporting the primacy of the Roman Catholic Church and the Pope's absolute authority.

5. *la chasse-galerie*: see Fourth Letter, note 8.

6. Jacques Poulin, *Les Grandes Marées* (Montréal: Leméac, 1978).

7. Daniel Defoe, author of *Robinson Crusoe*, and contemporary French writer Michel Tournier, author of *Vendredi: ou les limbes du Pacifique*. *Friday and Robinson: Life on Esperanza Island*, translated by R. Mannheim (New York: Knopf, 1972).

8. Allusion to *Suzanne et le Pacifique*, a novel by French writer Jean Giraudoux (1882-1944).

9. *intello*: trendy Continental French shortening of '*intellectuel*'; also used as a noun, *les intellos*, slightly derogatory, as in *poseur*.

10. *Les Eboulements*: in Charlevoix county, Québec.

EIGHTH LETTER

October

Every time I come back to Montréal, the city entices me more than before. I've finally gotten used to the architectural *bric-à-brac* and to the Babel-like language of signs which, for lack of imagination, will soon be called international. Yet Montréal has little to do with those capitals of concrete in modern style we usually associate, via the American model, with the internationalism of cities. Its architecture has been termed situational, an 'architecture that makes no claims to being one, with no architect [...] it eludes all established culture, any institutionalized system' (Jean-Claude Marsan).[1] Is this statement an apology for adulteration, or is it a tribute to singularity, to miscellany, to the unexpected? Montréal is a city you can only tame in time. It took me a while. Even today it escapes me. Despite the false unity provided by fancy street lamps planted by a megalomaniac mayor, I can't figure out where this city's heart beats, it seems to hide like some pimply teenager saving his dreams for initiates only.

How is one supposed to know that behind the brightly-lit but sad facades of *la Catherine,* the commercial street where you'll find a hooker next to a unisex boutique next to a shoe store, fabulous performances are taking place?[2] You enter Tangente as you would a wholesale carpet exporter's, from the second floor of a boring, graceless building. In a space barely larger than an artist's studio, I watched choreographer-dancers perform *Most Modern,* a series of 'present tense' sketches where passion combines with humour, lightness with the insolent precision of movement. Bewitchment of the body-as-spectacle modulated by the musical recitative of space-as-rhythm! Unpredictable choreo-graphics liberated from ritual as well as from academism. But why, I wondered, does a representation such as this one, based on a single

87

word, i.e. the title, announce itself in English? I was told that parody was intended, that it was necessary to find a clear expression to do a pastiche of postmodernism and be ironic about labels. Mere coquetry? Necessary alliteration? I wasn't quite convinced. Because last year, at a show organized by the periodical *Le Temps fou* at the Spectrum – also on *la Catherine* – I'd already noticed the anglomania of rock groups. And also noted in Michel Lemieux's admirable visual and theatrical compositions what I understood as a desire to be directly exportable, meaning ready for the American public, by using mostly English as intelligible language. Have the performing arts already given in to the demands of the market and of fashion? Or am I the one suffering from the linguistic over-consciousness well-known to *Québécois-es?* English? So what?[3] ask my New Age / *nouvel âge* friends, who have trouble distinguishing between knowing - English - to - know - it - because - it's - necessary - in - North - America and knowing - English - to - know - it - use - it - and - speak - it - fluently - if - not - all - the - time.[4] Because *c'est plus cool.*[5]

At Tangente, near Place des Arts, *la Catherine* is still relatively quiet and well-behaved, more like a banker than a shady character. The density of people on the prowl increases as you head east, where, within the confines of a few square blocks, the street resembles New York's seediest areas. This is where, Sunday nights, once again on the second floor – everything takes place at a certain level! – of a building just a little uglier than the rest, artists, students and collectors come slumming, surprised to find themselves in the same space which wears the terribly romantic name of Les Foufounes électriques.[6] It's a showcase for the talent of young painters who improvise in 3 x 4 to the sound of never-ending jazz. A master of ceremonies who has dry humour down to an art capitalizes on the delinquent side of laughter whose only justification is the effect produced. He is wearing a baggy checkered jacket and a wig, onto which the oddest objects are

grafted with clothespins. Were it not for this detail he could be mistaken for one of the straighter comics[7] who perform at *Les lundis des Ha! Ha!*,[8] the madcap Ding et Dong, a duo renowned for their repertoire of comical revelations, who officiate at Club Soda on Park Avenue. But here, everything is MORE, *too much* as they say.[9] Painting theories are left at the coat-check room along with the arsenal of decadent fantasies. Wasn't it a *Québécois* who, during a performance that attracted a lot of attention in Paris recently, buried art history in a large hearse in front of Beaubourg's prestigious outdoor plumbing?

In the 'chic cabaret Les Foufounes électriques' that evening, I was, like my male companions with half-shaven heads and blue hair, like my female companions with tightly cinched waists, filled with anticipation for this event. Knowing full well that we were its principal component figures. When the show started we were asked to make sure the artists had enough space around their canvases to be able to work. This request was not in vain. The club was so crowded that we were gaily stepping on each other's toes, practically forced to engage in conversation with our neighbour of the moment. Despite the circus-like atmosphere, I had some difficulty accepting the position of *voyeure* this game put me in so I was relieved when I heard the MC-auctioneer's bell go off, ending the round. The art market once again took on its literal meaning. Bets were placed. Everything was sold. Looking at these paintings which, each in its own way, were based on figuration or at least on referential clues, I reflected to myself that abstract art had had its day. I especially remember the fascinating expression of two heads, one enveloping the other in a kind of aura, in a painting by Louis-Pierre Bougie, and the uncanny presence, on another canvas, of 'real' slices of toast in quiet rows on a whitish stucco surface.

People in Québec seem fond of these improvised forms of competition where art borrows the mechanisms of its self-

evaluation from sports events. Merciless, the auction makes you or breaks you: though there are no winners and no losers in this game, popularity ratings are quickly demonstrated. So it's like a double execution. Keyed to on-the-spot consumption, the artist's products thus avoid the usual detour through galleries, those empty museums where even the most intense provocation meets a silent death. But doesn't such a method contain an inevitable tendency towards institutionalization? The system is all the more efficient for being so discrete. It has been seen in action at the LNI (Ligue nationale d'improvisation), an improv-theatre game copied from the LNH (Ligue nationale de hockey) where too often the spectacular wins over the show itself, cliché over exploration, process over discovery. Is this the price of the public's spontaneous support? Is there confusion here between actor's school and a striving for effect? In any case, this sport of *Québécois* improv is more 'national' than we realize.

The discontinuous, the fragment, humour, are the signs and symptoms of the contemporary I find in yet another den of Montréal cultural life, Espace libre on Fullum Street. It's an old fire station turned into a theatre. A neutral, easy-to-transform space, though a little bare, where spectators, arranged in clusters around the central space, must engage in various acrobatic feats before reaching the benches or chairs that have nonetheless been thoughtfully provided, as if only to conform to the rules of the genre. Just the same, audience participation, though less direct here than at the LNI and Les Foufounes électriques is not ruled out. While it still operates through humour, it hinges more on the 'slippages' associated with dreams and poetry. In *La Californie,* Jean-Pierre Ronfard (director of the Théâtre expérimental, coach of the LNI and originator of *Le Roi boîteux*) and his troupe succeed in reconstructing some of the best moments from the LNI and from Shakespeare's complete works. Collectively written and built around a certain number of pre-determined tableaux, *La*

Californie re-presents images of our time which the actors-authors glide into with the subtlety of poets-comics intent mainly on performing their own strokes of inspiration and then turning them around to do a 'take' on them. Are we here or are we elsewhere? In what dream-space California are we seeing these images we so easily recognize? For the first time since I've been going to Espace libre, the big red firehouse doors aren't open onto the street, so the representation space remains closed, thus internalized – which explains the recurrence of certain tableaux – and transposed by references to a work, a style, a cultural theme: Duras, Metro-Goldwyn-Mayer, chicken in the basket, the Théâtre expérimental des femmes and pornography.[10] California? It is everywhere and nowhere. Most of all it is a rhythm, the rhythm of the little ball danced and spoken by two actors who, like one of writer Suzanne Jacob's characters, decide to 'discretely veer off from their trajectory.'[11]

This California, a joy for the eye as well as for the mind, is vastly different from Godbout's. In a documentary titled *Comme en Californie,* he shows that Québec's relationship to America, long confined to the beaches of Maine or Florida condos, not to mention the obligatory weekends in New York, now plugs into the California connection. Nothing more 'specific' seems to have been found, in order to escape the runaway tyranny of this best of all possible worlds, than to dive headfirst, or rather heart and soul first, into the reassuring utopias of Los Angeles or San Francisco. But in a context where everything is inevitably planetary, can marginality, or so-called alternative culture, be conceived of without immediately taking on global proportions?

I would term the art shown in Montréal today more societal than social, more preoccupied with deciphering/parodying the signs of a civilization than with redrawing the figures of its representations and of its future plans. Like the city itself, it is situational art rather than in situ. It has no doubt temporarily

given up on changing life and, at best, accepts to reveal its forms. Which explains the importance of the sketch, the tableau, the scene, all of which can be found, in varying degrees of stylization, in Ronfard's work as well as at Tangente, at Mimes Omnibus and in Montréal Transport performances. It is, in a sense, the triumph of the 'revue,' once confined to variety shows but now promoted if not transformed by multi-media groups. Walking up l'Avenue du Parc (which used to be known as Park Avenue) on my way to see *Ça,* Montréal Transport's latest show, I noticed that this Club Soda I was headed for was located just upstairs from Tapis National Carpet, which was located next door to Fellini's restaurant and across from La Villa du Poulet, immediately to the right of L'Institut de personnalité Jean-Guy Leboeuf.[12] A little further down the street, a porn movie theatre was sold-out. All of this was re-viewed again in *Ça,* with music and the actors-musicians' high spirits added. Does the consumer-producer society trap artists in the fast lane of production-representation-derision? Where is the madness of the Grand Cirque Ordinaire, that chorus of anti-authoritarian clowns immortalized by Roger Frappier's film, who once upon a time deeply disturbed the *Québécois* scene with their passions and their paradoxes?[13] But there must be a reason the dream has been hijacked towards immediacy.

It's a shame you can't come to these places with me. I'm looking forward to being curious together, to comparing comments. Also to seeing through your eyes. This climate you're so afraid of, would you believe that one comes to forget it enough to live with it? I've come to prefer it to the monotony of ours where, as your letters seem to indicate, my friend, you are at a loss. I enjoy the atmosphere of creative effervescence I'm living in which gets each and every one of us caught up in its whirlwind. A certain kind of mimesis is probably necessary at this time. When artists give up on disconcerting the public, perhaps they can only be more successful, with and because

of this audience, in invoking the many faces of the world. If Montréal's calendar of events is any indication, this city is 'a moveable feast,' a perpetual party. The academic-type party of Place des Arts opera and of Broadway shows which institutional theatres re-stage, outdoing each other with each production. The narcissistic, incestuous party where artists voluptuously roll around in the images that brought them into the world. The nostalgic party in homage to Félix Leclerc given a modern twist by younger people bold enough to invoke a precedence. A sad party too, that failed performance called 'Art et écologie,' where, on a cold night in the Old Port, a bored and silent crowd watched Apollo flirt with Dionysus without understanding a thing, except that a semi-nude woman was lamenting her fate on the wind-blown scaffoldings while Tarzan-astronauts fought in front of (over?) her; except that a lone sculptor named Armand Vaillancourt was gauchely attempting to put his work into the context of Québec in the Eighties, a gesture perceived as a dangerous anachronism. The myriad voices of a multiple-site party were heard in the four corners of the city thanks to the 'Poésie, ville ouverte' event. And lastly, the intimate party of words stripped bare, whispered in *cafés-théâtres* and *boîtes à chansons,* which are quietly making a comeback.[14]

Should I confess that in spite of all this I saw only a small part of what Montréal has to offer its evening crowds? And I haven't even mentioned movies yet! You'll understand that between the live shows, the books, and my research which is progressing too slowly, I'm constantly torn. Yet I thought I did perceive, in my recent readings, the same 'will to story' as discernable in other modes of expression. A will to story associated with the practice of the 'scene,' of the self-contained fragment, like in the short stories of Gaétan Brulotte, of Marilú Mallet, of Monique Proulx and in the *Dix contes et nouvelles fantastiques* anthology edited by André Carpentier. *Québécois-es* writers have learned from the Latin Americans

93

that passionate attention paid to the object, to true-to-life detail, to minute movement, gives rise to the strangest exchanges between realism and fantasy. Indeed, to what 'order of discourse' can you link Madeleine Monette's *Les Petites Violences,* that veritable stroboscopic study of emotional relationships?

As for parodic intention, in literature it tackles the forms and codes of fiction. In her *37 1/2 AA* – referring to Cinderella's presumed slipper size – Louise B. Leblanc rewrites a Harlequin romance, so cleverly pulling the genre's strings that an unsuspecting reader – male or female – might be completely taken in. With this device the author blurs the line(s) between highbrow literature and popular literature, juxtaposing the story and an analysis of narrative processes. In the same way that the movie *Diva* refers back to a tradition of detective movies, or the way Ronfard's *La Californie* revises a certain kind of theatre.

Humour is also what first distinguishes Francine Noël's admirable *Maryse.* Reading this novel was a distinct pleasure and I haven't resisted the temptation of sending you a copy. But there are so many threads in this wide-angle narrative that I'm not too sure now what it is exactly that connects me to it in such a friendly way. Is it the chronicle covering the years 1968 to 1975 which gives the impression through clear-cut scenes of reconstructing a historical totality (on the subject of the War Measures' Act, notably, the episode with the cats is more instructive than most informed analyses)? Is it the resolutely 'Montréal' perspective? Is it how the characters stand out in theatrical relief? Is it the romance plot pacing and framing Maryse's inner growth? Is it the critique of institutional and pseudo-scientific systems? Or the atypical angle on women which contrasts with the stereotypes habitually perceived as fictional? But what would all these threads be without the delicious impertinence of a style that transforms every event into a

lush verbal flow? In Francine Noël's work, the intelligence of dailiness finds its expression in a great versatility of linguistic effects and in a no-less-great mobility of language. When at the end of the novel, Maryse, alias Florentine-Cinderella-Eliza Doolittle, confers the status of writer upon herself, she is claiming the right to use and to abuse all languages, joyously appropriating *joual,* English and the studied French of professor André Breton [sic] all at the same time.[15] The narrative voice, however, respects the purest conventions of French syntax: *'Il ne se passait rien d'autre que des mots et l'hiver sévissait.'* ('Words were the only thing happening and winter was upon us.')[16]

Maryse is a best-seller. This is rather rare in Québec, except in the case of autobiographies tinged with scandal or at the very least with sensationalism. Are writers preparing to reunite with their public after a lengthy separation some have called a divorce? If so, at the cost of what compromises? All around me I hear accusations of stooping to facility. Obviously there is something a bit overdone in the caricature sometimes, and this jars with the narrator's presumed omniscience. But it's as though there were, from the start, something indecent and unworthy in the collusion between a novelist and her readers. The concept of literature that has long prevailed here, and which still does to a point, says that a best-seller, especially if published in Montréal, is necessarily suspect. There appears to be great difficulty in accepting the plurality of tendencies which develops de facto in any literary production and testifies to its maturity: modernism and the adventure of a story, humour and social-political content. At a time when 'isms' are increasingly being dropped, just when highbrow culture and popular culture are sharing borders in the parodic itinerary and mixture of styles, is it still possible to state the necessity of playfulness with incorrigible seriousness? If writing is a celebration (*une fête*), isn't reading its

desirable, not to say necessary, amplification as well? A new reading pact is being created, which goes beyond the corruption of language.

To my mind, what was called the Age of Speech corresponded more closely to an Era of Proclamation and of poetry's power as manifesto. Wasn't there a belief that naming things was enough to make them exist? Then came the formalists, who sought to question the ideology at work in language and change the models of discourse. This was still, though in a different guise, the Age of Poetry: laboratory poetry, wary of lyricism, attentive to its own processes. Meanwhile, and parallel to this, writing in-the-feminine, eclectic, *gourmande,* was inventing the forms it needed. From then on, Québec literature seemed oriented toward what I would call the Age of Prose: an everyday, tumultuous, carnivalesque prose. The prose of Yolande Villemaire, Yves Beauchemin, Francine Noël, those modest or wild swervings towards the images and signs of the present. A prose indebted to Réjean Ducharme, Jacques Ferron and the Surrealists. A prose in constant tension between the will to say, to unveil, to seduce, and the desire to contradict itself by playing with reference as if it were the compulsory and flexible accessory used in sports games. So the mirror games of the *nouveau roman* give way to the representational games (*jeux de scène*) of what, after Bakhtin, must be designated under the term 'dialogism.'

And yet, in the very midst of this profusion and just when *Québécois* literature and culture are being anthologized, institutionalized, internationalized, one question still remains unresolved. Writing, creating: who for? what for? What are the stakes of culture in a quasi-country threatened with gradual disappearance? Doesn't *'L'impossible pays'* (the impossible country), as in the title of a novel by François Hébert, legitimize creation only when culture is considered harmless entertainment?[17] At what point does the celebration become subversive and anti-establishment? Does the political silence of

creators busily organizing the mechanisms of their own survival – without ever really succeeding – still have value as strategic withdrawal? The personal is political: no need to go back on that, certainly. But isn't the political quietly, and surreptitiously, taking advantage of this to redefine itself as the personal? To what extent, however, is the creative act not the most political act conceivable?

At the core of a silence inhabited by a thousand words, some concerned voices are making themselves heard. The voice of Yves Beauchemin:

> The recent explosion of our literature reminds me of an apple tree flowering in the middle of winter. (Panel discussion, *Possibles*.)[18]

of Gaston Miron:

> Any culture wishing to fulfill itself as an anthropology in the world and in history, to experience itself, to enact itself, to flourish, must find its own meaning, represent itself, be self-sufficient within a context of interdependence and exchange, and this implies that it also has, like any other culture in the world, its own political expression and dimension.
>
> [...] The future of Québec literature and of its love affair with language is tied to the fate of the people and of the culture that sustains them. Having to state something so obvious is enough to make one cry. (Acceptance speech, Prix Athanase-David.)[19]

of Madeleine Gagnon:

> You see, but whom? we are completely dilapidated, constantly deprived.
>
> As a result of being without great works of art, or rather of being from empty white works that melt like snow and, like snow, are eternal. Or else it is much too

hot. A country that is not one: *pays de fous,* a wild one. (*Dérives.*)[20]

You'll notice, Sarah, that questions haunting creators everywhere take on peculiar relief here, an exemplary sharpness.

[...]

Everytime I come back, Montréal entices me more. I'm not bored in this city of *la presque Amérique* – in almost-America. I'm increasingly sure I'll be staying. Precisely because of this constant imbalance of meaning which staggers even the most dazzling of certainties.

I'm less and less of a stranger in this inalienably strange land.

Yours ever faithful,
Roxane

Translator's Notes

1. Marsan: Montréal architect, Dean of Université de Montréal's Faculté d'aménagement, well-known for his books and articles about Montréal's urban planning, design, etc. Translation mine.

2. *la Catherine*: term of endearment for Saint Catherine Street, Montréal's largest downtown commercial artery.

3. So what?: in English in the text.

4. New Age/ *nouvel âge*: in both languages in the text.

5. *cool*: in English in the text – widely used in Québécois French since the Sixties.

6. Les Foufounes électriques: literally, electric buns/ass.

7. straight: in English in the text.

8. *Les lundis des Ha! Ha!*: comedy Mondays.

9. *too much*: in English in the text; widely used in Québécois French, like 'cool' and 'straight.'

10. chicken in the basket: in English in the text.

11. Suzanne Jacob, translation mine.

12. *La Villa du Poulet*: Québécois appellation of Kentucky Fried Chicken.

13. The complete title of Roger Frappier's film is *Le Grand Film ordinaire ou Jeanne d'Arc n'est pas morte, se porte bien et vit au Québec* (1970), inspired by Le Grand Cirque Ordinaire's show *T'es pas tannée Jeanne d'Arc* produced by the Théâtre Populaire du Québec.

14. *cafés-théâtres, boîtes à chansons*: Sixties'-type folk houses, coffee houses.

15. Florentine Lacasse, main character in Gabrielle Roy's *The Tin Flute*.

16. excerpt from *Maryse*, translation mine. Le nouveau roman cf. First Letter, note 12.

17. François Hébert, *L'Histoire de l'impossible pays* (Montréal: Editions Primeur, 1984).

18. Beauchemin, translation mine. *Possibles* is a multidisciplinary cultural periodical founded in 1976, of which Lise Gauvin is an editor (cf. Fourth Letter).

19. Miron, translation mine.

20. Gagnon, translation mine.
 Dérives, inter-cultural and multidisciplinary cultural periodical founded in 1975 by Haitian writer Jean Jonassaint (cf. Fourth Letter).

NINTH LETTER

December

Today everything is cracking, everything is falling. May the end of the world resemble this decadent phantasmagoria which, from my window, attracts and holds my gaze! What a rare spectacle, the sight of trees bending in their sheaths of ice as though embedded in glittering flesh. I feel immersed in a land of nameless elves and gnomes, of mischievous spirits able to associate heaviness with transparency, the disturbing with the beautiful. Complete disorientation, total parenthesis. Alongside schoolchildren skating on the sidewalks, car drivers venture between the tree trunks and branches littering the roads. Half the city is without electricity. Soon I'll be able to keep writing to you only by candlelight, like in the bygone days that seem so far away. Faced with this unpredictable extravaganza, I find myself imagining a *fin-de-siècle* cataclysm.

And yet this time we felt so sure that winter was here. A clean, definitive winter. So much so that I'd finally come to recognize the poets' famous verses, Miron's '*la beauté fantôme du froid,*' Nelligan's astonished: '*Ah! Comme la neige a neigé!*'.[1] My friends relived childhood joys and included me in their projects. At least those who, for reasons of ideology, taste or simply for lack of money, have given up on Florida, Mexico or the Caribbean. I've noticed that professors and artists generally prefer Mexico and Cuba, while the Francophone business class is more inclined to head for Guadeloupe or Martinique. Florida is increasingly left to large families and rich students who, in order to take advantage of lower airfares, sometimes dare to ask their teachers to prepare a special in-advance exam for them. But the people I see most regularly don't need to go around parading their exotic tans against the city's dubious whiteness. Nevertheless, they're always pretty

101

unhappy about the weather. I see this, if not as a characteristic, at least as a very *Québécois* trait: the seasons, and winter in particular, are never what they should have been or should be. The fact that *Québécois-es* talk about the weather all the time probably comes from their English side, while griping about it day in, day out, is no doubt an effect of their French side.

Is my new-found companions' incredible power of adaptation due to climatic fickleness? I don't want to start theorizing on the psychology of a nation here, nor associate myself with Madame de Staël's overly broad classifications.[2] It's just that all around me I've noticed a marked propensity for being easily seduced by fads and trends of all kinds and, in this so-called traditionalist society, I'm still looking for the traditions. To the point where I wonder if the motto *Je me souviens* isn't there to remind a collectivity strongly tempted by amnesia that history does exist.[3] The only tradition I can see in Québec today is one of rupture. Haven't the people of Québec, in barely twenty years time, thrown out the old furniture, then stripped it and polished it, only to accuse it, as is presently being done, of every evil under the sun: anti-modernism, *passéisme,* the status quo, non-productivity, etc. Once a muse for some of the creators, macramé has suddenly become the equivalent of the outdated devil of old-fashioned folktales. From now on, Marilyn Ferguson's *The Aquarian Conspiracy* is required reading, a must.[4] It's trendy to be interested in the martial arts and/or aerobics, to see an acupuncturist or a chiropractor, and to have your astrological chart done from time to time, just to check out your interplanetary antennae. To participate in individual therapies that work through group activities. To talk about computers regularly and wonder whether or not to have one at home and if this machine will, in fact, bring about the much anticipated global revolution. Novelty is always presented as an imperative here, as an absolute, an encompassing self-contained sphere outside of which you simply

cannot exist. You say you find such openness very attractive? Yes, but to what extent isn't it also evidence of a kind of basic insecurity which, from a past standstill, has deviated into what has been called *'une culture passoire,'* a sieve-like culture? As for the political question, more and more it seems to be considered *un sujet qui n'est pas in,* a not terribly hot topic.[5] In good Québec society these days, talking about independence is tantamount to making ill-chosen remarks. I've already told you that the thing to do, in certain circles, is to blame Québec's current leaders for world-wide economic problems and for subjection to the crown of England. Meanwhile, the Justice Minister who approved the 1970 War Measures' Act has been elected mayor of a well-to-do Montréal suburb, Bourassa II has replaced Bourassa I, and everywhere he goes in the world, Trudeau flaunts his prestige – a French Canadian who-has-made-it!

Je me souviens, the saying goes. But what is it one remembers? To eat turkey at Christmas and ham at Easter? That winter is long and that they were once members of the RIN the same way they now support disarmament?[6] What Québec remembers in spite of itself is, to my mind, much deeper and more harmful. It's a permanent collective shame everyone keeps alive inside and which resurfaces like a groundswell after every defeat. Defeatist behaviour meaning that it's easier, in this quasi-country, to stab each other in the back and to disown oneself than it is to challenge the menacing, triumphant, and therefore highly seductive, other. 'This nation has remained itself through fatality and alibi,' wrote Borduas in 1948 in the *Le Refus global.*[7] The manifesto also denounced the 'abdication of the elites' and French-Canadians' atavistic fear. Escaping, in other words, not taking part in; this Québec reduced once again to a guilty silence: this is what many seem to be repeating nowadays, while discretely veiling their faces and turning their backs on the collective fate. Others more aggressively adopt the attitude of disappointed lovers and, for

want of a single target, make fun of their own kind. Preferring the tone of *Cité libre* to that of *Le Refus global* and of *Parti pris,* they compete with each other in degrees of contempt, indifference, individualism and, inevitably, of cynicism.[8] Then again, they might sink into what *Le Devoir* editorialist Lise Bissonnette appropriately terms *le discours mondain de la déprime* – the trendy discourse of the urban blues.

When I first came to Québec, I almost got taken in by the vitriolic tone myself. Even before my arrival, in fact just as I was boarding the plane at Charles-de-Gaulle Airport in Paris, it took me some time to figure out to which language my travel companions' unidentifiable murmur belonged. They were talking to one another, but only a few monosyllables were coming out of their mouths. Their strangled voices seemed to go full-circle round their palates and come back to nestle in their throats like in some cozy nest. Mouths remained almost shut, lips barely moved. I couldn't figure out how they could communicate given such a lack of sounds. So was this it, North America's *'francophonie'*? I could already see myself mired in the 'lousy French' some had made the object of merciless propaganda.[9] Needless to say I was very disappointed, but at the same time I was imagining a possible brilliant career as a speech therapist. What struck me most was how all these people talked to each other very little and, except for basic exchanges, remained silent. Then I noticed I'd fallen into a group of businessmen returning home from a reconnaissance mission in Europe. When I heard the man in the seat next to mine speaking English to his companion, I couldn't help admiring the clarity and precision of his elocution. His delivery had suddenly, magically, become clear and *deutlich,* as they say in German.

I resisted the impulse to generalize my first negative impressions and even preferred not to share them with you. This precaution was more than wise. If I hadn't been careful, I would quickly have been branded a *maudite Française,* for

what with my ready-made judgements and my foreign accent, people are often mistaken about my origin. What has happened since Pehr Kalm wrote in his *Voyage de Pehr Kalm au Canada en 1749*:

> Everyone here is convinced that the common people of Canada ordinarily speak a French more pure than in any Province of France and that they can, assuredly, compete with Paris.[10]

I started really listening to people and questioning not the results of their performance but rather their relationship to speech. I know that the *bourgeoisie d'affaires* is the class most affected by this cancer of the formless and the inaudible. Renouncing its obscure or peasant origins, it has in most cases traded its linguistic awareness for a quantity of coins of the realm, which it clings to as if to some lost and found identity. But on the whole I've no trouble talking with *Québécois-es* and find that, apart from the inevitable and desirable lexical variants, they speak more or less the same French as in France. Sometimes it is even more refined. People are scandalized when I dare to use words like *starter, weekend* and *parking* when I speak French. The difference is not in the syntax, nor in the vocabulary, nor even in the accent, which varies greatly according to region and level of education. The difference lies in an unconscious feeling of fault and of fraud, in a kind of age-old fear of touching language, as if touching the forbidden body of the mother. It is an impeded speech, the *Québécois-es'* speech, for they've long been confronted with normative and academic criteria: '*Bien parler c'est se respecter*,' they were constantly told.[11] '*Parler c'est se respecter*' is what they should have been told, says a friend of mine from Liège.[12] And I agree.

Now that is a scandalous statement to make on a continent resonating with the shameful yet explicit watchword: 'Speak White.'[13] An often hesitant, faltering speech. Should you say

105

ampoule or *lampe* for 'lightbulb'? *Boîte, conserve* or *cannette* for tin can? Chasms of silence open up between 'hamburger' and *hambourgeois*.[14] Walls of stuttering go up around the shifting of signifiers. I've slowly come to realize that, for generations of *Québécois-es,* oral expression is both something of an offence and something of a feat, while they handle written language with much greater self-confidence. Even my fellow students panic before oral exams, preferring long written essays to a few minutes' verbal interrogation. This is what Jean Forest, in his linguistic autobiography titled *Le Mur de Berlin, P.Q.,* calls being sentenced to poetry.

Yet in no other country have I seen such admiration expressed for people who are skilled speakers, *monologuistes,* announcers, orators, politicians, persons capable of holding the public's attention with their words. So much so that I wonder if speaking isn't, up to a point, always linked to the Word. Don't Trudeau and Lévesque owe a good deal of their prestige to the sense of repartee which allows them to send a hoard of journalists reeling in a matter of seconds? In everyday life the *Québécois-es* I know don't talk to each other much. Here as elsewhere, women are more conversational: their range of interests is much wider than men's and they enjoy talking about making jam as much as about the latest best-seller.

Although public speaking remains almost exclusively a male prerogative, it seems to me that on this question of the relationship to discourse, *Québécois* males are particularly hung-up and tongue-tied. I'm getting tired of being told I'm 'not bad at all,' 'not unpleasant to go out with,' and 'not hard to like.' A rhetorician could locate in this habitual discourse a profusion of litotes, redundancies (*descend en bas, monte en haut*) and antitheses ('For a strong Québec in a united Canada').[15] As for the romantic vocabulary, I think it's still reserved for poets and women. Between François Paradis' marriage proposal in *Maria Chapdelaine* (*Vous serez encore*

icitte au printemps? – You'll still be here come spring?) and a more recent hero's declaration – Michel Paradis in Francine Noël's novel *Maryse* – the evolution seems all very relative. Doesn't the latter Paradis admit his love to his girlfriend only after they've been living together for five years, and then just as she is about to leave him?
What is it they fear? Love? Language? Women?
I'll keep thinking about it, as I send you my best regards,

Roxane

Translator's Notes

1. '*la beauté fantôme du froid*': 'the cold's ghostly beauty' from 'The Age of Winter,' in Gaston Miron, *Embers and Earth (Selected Poems)*, bilingual edition, translations by D.G. Jones and Marc Plourde (Montréal: Guernica, 1984). Also in Plourde's anthology of Miron in translation, *The Agonized Life*, cf. Sixth Letter, note 7.
 '*Ah! Comme la neige a neigé*': Nelligan, from the poem of the same first line. 'Ah! how the snow falls free!', from 'A Winter Evening,' in *The Complete Poems of Emile Nelligan*, translated and with an introduction by Fred Cogswell (Montréal: Harvest House, 1983).

2. Madame de Staël: French writer (1766-1817). In her work *De la littérature, considérée dans ses rapports avec les institutions sociales* (1800), she put forth the hypothesis that two kinds of *esprits* and two literatures exist in Europe: one in the south characterized by intelligence, order and reason, and the northern one made of sentiment, dreams and enthusiasm.

3. *Je me souviens*: 'I remember' – Québec's official motto.

4. must: in English in the text. Now used in French, popularized by French jewellers Cartier's advertising '*les must de Cartier*.'

5. *in*: in English in the text.

6. RIN: Rassemblement pour l'Indépendance nationale, radical political party of the Sixties and Seventies.

7. *Le Refus global*: from Paul-Emile Borduas, *Ecrits/Writings, 1942-1958*. Introduced and edited by François Marc Gagnon. Translated by FMG and Dennis Young (Halifax: The Press of the Nova Scotia College of Art and Design, 1978). Co-edited by New York University Press, New York. Translation here mine.

8. *Parti pris*: influential political and intellectual review of the Sixties (1963-1968) whose three objectives were secularization, socialism and independence for Québec.

9. 'lousy French': in English in the text.

10. Pehr Kalm, *Voyage de Pehr Kalm au Canada en 1749* (Montréal: Editions Pierre Tisseyre, 1977), 674 pp. Pehr Kalm was a Swedish traveler, trained botanist and amateur ethnologist who made detailed notes of his observations during his trip to the New World in 1749.

11. '*Bien parler...*': 'Speaking well is a sign of self-respect.'

12. '*Parler...*': 'Speaking is a sign of self-respect.'

13. 'Speak White': see Second Letter, note 4.

14. 'hamburger'/*hambourgeois*: *hambourgeois* was the much ridiculed word proposed by l'Office de la langue française as a replacement for 'hamburger.' It was used on menus but rarely in spoken language. I recently saw an interesting compromise: hamburgeois.

15. *descend en bas/monte en haut*: untranslateable colloquial redundancies, akin to: 'go down the downstairs/down elevator' or 'go up the upstairs/up elevator,' like 'unthaw' or 'dethaw' for 'thaw' in Canadian English.

TENTH LETTER

March 8

Despite their emancipated airs, *Québécois* women don't seem to have made much progress in gaining rights: many of them remind me of those veiled silhouettes you still see in our streets and markets. In theory, they have full and equal rights. In practice, they have very little power, except the one linked to the lowly responsibilities of daily life, to 'keeping the wheel turning,' to maintaining in place systems whose mechanisms most often escape them. Even among the people aged twenty to thirty whom I see regularly, the girls 'come second' and easily adapt to the role of 'moral and material support' the boys generously allow them to play. On the face of it, Québec society isn't sexist: commercials show more and more men washing dishes or vacuuming, more and more women driving trucks. Certain jokes just aren't heard anymore, at least not in front of women. Men have learned to 'watch it.' But beneath this newly polished surface, behaviours haven't changed much. When a woman receives an important appointment, the most extravagant rumours immediately start circulating about her private life, depicting her as a nymphomaniac or a virago. As if the entire male species were suddenly endangered! I'm told that only a few years ago in Québec, male students scrupulously avoided being seen with their 'fellow' female students. The girl had to be a good grade or two behind the boy: such was the price of a harmonious couple. Today, some men complain that too many women are speaking their minds. Too many? Please! You can count them on the fingers of one hand. That's still too many, say the men, brandishing the spectre of *Female Power*.[1] Like in Manitoba, where they've manufactured the myth of *French Power* to silence the six percent of Francophones in the population.

Why so many comments about women's fate all of a sud-

den? Well, because it's March 8th, it's snowing, and I feel like writing to you. This is my way of being good to myself, of giving myself a gift, on International Women's Day. It didn't take me long to realize that what would please me most would be to bracket all the more or less urgent things requiring my attention so I could talk to you. Though I don't quite dare call this activity 'creation,' I confess I do have the same misgivings about it that women artists have about their production.

An article based on research by a woman art historian published in this morning's *Le Devoir* says it is particularly difficult for women painters to find their place in the art market. Buyers hesitate to invest in 'careers' that may end abruptly. Women themselves are easily persuaded to put their creative process aside for more useful, more undisputable tasks. Many turn to crafts or interior decorating, preferring the functional justification to the luxury of 'art for art's sake.' Others have difficulty believing that their art practice is important enough to devote most of their time and energy to it.

Among those who persevere, in literature as well as in the fine arts, many are single. It's as if men have trouble adapting to the support role women have historically held in the lives of their creative gods. 'I can't breathe when I'm around you,' says the male companion of the heroine in Margarethe von Trotta's film *Friends and Husbands,* as he leaves her.

All this to say that if you weren't there awaiting my letters, Sarah, commenting on them, prodding me to go on, I'd have stopped writing a long time ago. If art is initially born from an ability to communicate with oneself, it's difficult to imagine any art not finding, at the very least, a minimum of reception. So, for better or for worse, you must share the responsibility for these texts with me! I've noticed that men are often jealous of this solidarity now bonding more and more women together. Every time men lose one of their prerogatives, they feel excluded, unhappy, worried about not getting the exclusive attention they'd been the object of till now.

Here I am talking to you about men and women as if there was a homogeneous male collectivity on one side and an equally uniform female collectivity on the other. So let me specify, then, in case you have any doubts, that my generalizations in the plural are only the sum of my observations in the singular, gleaned from what I've read and who I've met. I'm passing them on to you, obviously to satisfy your curiosity, but also because my condition as 'recent arrival' has made me question 'old stock' *Québécois*'and *Québécoises*' behaviour more than they do themselves.

Such precaution, such circuity, such preambles, right? Are men really so thin-skinned that they cannot accept any opinion having any purpose other than to jack their pedestal up by a notch? Not thin-skinned, but vulnerable, because of the ego-wounds feminism has inflicted on them. In fact the word itself has become a kind of suppressed one, uttered only in whispered tones. For many men it immediately evokes the image of Diana the Warrior Woman, leading an army of Amazons carrying poisoned lances. What a joke, when women themselves are in the throes of trying to get free of their complexes – be it Cinderella's or Jocasta's! When a large number of girls are still dreaming of the true love that will give their lives meaning? But *Québécois* society has, in a few short years, experienced such upheavals (industrialization, secularization, the democratization of education, *indépendantisme*, the Referendum setback, and so on) that everybody is sort of destabilized and forced to perform amazing acrobatic feats so as not to land flat on their ass on the sidewalk, like someone who has just slipped on a banana peel. In fact, my impression is that without admitting it overtly, inside, every *Québécois-e* feels like he or she has run into their banana peel. Some say it's René Lévesque's fault, others say feminism is to blame. You find whatever targets you can.

Getting back to feminism – which is always designated in the singular with no attention paid to context – a friend and I

had a lot of fun the other day attempting to draw up a typolog-
ical sketch (notice how cautious I am!) of *Québécois* male atti-
tudes towards this matter. Proceeding as scientifically as pos-
sible, but always according to empirical data, we were able to
establish four main categories. I should specify that these
categories aren't really airtight and that all of them can be
found simultaneously in the same city, although, from what
I've heard, they seem to have appeared in chronological
order.

First came the sympathetic, generous attitude of those who
felt uneasy once they became aware of their privileges, of the
gap between what is asked of them and what is required of
women. These men started doing groceries, changing diapers
and sharing chores while hiding to read *Playboy* and *Pent-
house*. They sometimes modestly avert their eyes from
women's breasts, though the women have no such expecta-
tions. Frankly speaking, these men are heroes. Haven't they
wiped out centuries of male supremacy in one fell swoop?
They'd be happy – for gaining female companions can only
be a source of delight – to be given full credit for their cooper-
ation. But *one* sometimes forgets to express the gratitude they
so rightly deserve.[2] Then they feel misunderstood, alone in
front of the TV set sometimes, wondering if, in the end,
they've really gained anything in the exchange. They have a
hard time glueing back together the various pieces of their
identity, lost amid the thousand and one concerns of daily life.
Sometimes they even dream of that blessed time called the
matriarchy when women were absolute 'masters' of the
kitchen, which in those days was a big beautiful room with a
humming woodstove, while they (men) had the no-less abso-
lute enjoyment of their time and of other little things such as
the State.

Another widespread attitude consists in treating feminism
with irony and subjecting its slightest manifestations to the
merciless censorship of ridicule, in the finest Molière tradi-

tion.[3] If a woman talks about her difficulty in overcoming the constraints linked to her historical condition, she is immediately suspected of narcissism, of navel-gazing, of collectivism [sic], when she isn't bluntly said to be letting her menstrual period get the better of her, or not preparing for menopause very gracefully. Those males are generally very polite when you meet them. They pretend they're listening. They even respond on occasion. But as soon as your back is turned they draw the curtain on what you've said or done, ignore it or trash it. I was astounded, one day, to discover that this attitude was personified, that it even had a first name: *Nadine,* a pseudonym invented by a group of young men working for a well-known journal, *Nadine* apparently comes from *nada,* meaning 'nothing.' (Unless it is derived from Canada, which means almost the same thing, in terms of etymology.) For several issues, *Nadine* was the caricature of the female species, the only 'woman' authorized to express herself in the publication's pages. The editors had a good laugh. This brand of humour was apparently helpful for their intellectual hygiene. They also apparently had nothing against women on a one-on-one basis, but against feminism in general. They had nothing against women but were snuggled right up against them, *pas contre mais «tout contre.»*[4] Nadine, *nada....* Phew! Isn't triviality the reason why a whole section of cultural history transmitted by women has been ignored?

Our informal survey has allowed us to determine a third attitude regarding feminism. One stemming from both astonishment and incredulousness, and which could be characterized by Julius Caesar's famous remark: *Et tu quoque, Brutus.* These men generally appeal to normally-constituted, well-educated women with relatively well-paying, socially well-regarded jobs. Telling them they don't 'need' feminism because society is more well-disposed towards women than ever before. Haven't they 'succeeded' and accomplished what they wanted? Men who say such things are generally prepared

to put their faith in women as well as men. I'd qualify this attitude as *cité-libriste* relative to the one prevalent at *Parti pris*: a belief in the magical power of talent, of ability, in a certain form of liberalism where virtue is eventually rewarded.[5] For them, the feminist movement is a challenge to universality and to reason. It's Trudeau against Lévesque. For doesn't he use a similar argument to tell Québec that its desires aren't reasonable, that its claims are unjustified? That really, *La Belle Province* has no reason to complain and complicate life for all the other provinces? Just like Québec on the federal chessboard, women still often find themselves in a ratio of ten to one on various Boards of Directors. But isn't feminism a virus they, women, could be exempt from? I'm told that this remark has been overheard in certain Québec milieux from time to time, while in Ottawa, to the contrary, there is growing awareness of the political capital to be gained from a bilingual profeminist commitment making the little *Québécois* border null and void. Those who say women don't need feminism generally forget that it's precisely because of feminism that woman can do without... feminism. Personally, I fail to see how a woman claiming her double *appartenance* as a woman and as a *Québécoise* is in any way undermining intelligence and common sense.

The fourth and last attitude itemized was the counterattack. Men react, threaten, take the offensive. Haven't women reduced them to the status of the oppressed, of wimps, of pariahs? Haven't women taken up all the room? Virginia Woolf is us, they say. Some of them hold meetings, pool resources, form coalitions, not to talk about affairs of State, as they have always done in their very private clubs, but just to chat about their performances in sports or in bed. Secret societies reappear, closed to women. Others throw their hands up, loudly protesting and swearing on their mother's head that the thought of raping or beating a woman has never crossed their mind. At best they'll admit to pinching

their little sister's behind. While others still, breaking the law of silence women have apparently imposed on them, dare to say out loud, without fear of being mistaken for phallocrats or misogynists, what they think inside. They're fed up. With what? With women's writing, in particular: 'They talk about their aches and pains, their hang-ups, they give detailed descriptions of their navels and their vulvas, of their smells, their cramps and their menstruations, of their clitoral and vaginal orgasms' (*L'Actualité*, March 1984). Fed up with feminism and feminists too. It bugs them.

These men believe themselves victims of a great plot expressing itself by what they call the 'Queen bee syndrome,' the aim of which would be to eliminate males after use. According to a (real) psychiatrist, feminism is even responsible for bringing about the end of romance. Worse, the death of desire. Young people 'don't want to be subjected to the feminist discourse. They would rather avoid discussion and get straight to the point using the most simplistic weapons or traps. They take the shortest road between desire and satisfaction.' The next thing you know they'll be accusing feminists of being the cause of rape, incest and impotence. The Queen bee syndrome? More likely the resurrection of the Pandora myth according to which woman is the source of every evil visited upon humanity. 'I find much greater animosity coming from men,' said Simone de Beauvoir in an interview in *La Vie en rose*, the *Québécois* feminist magazine, 'due to the fact that there is more freedom for women now. In particular, the famous sexual freedom you always hear about, which men benefit from because things always go their way; they tell themselves that, after all, a woman can have sex anytime, any way, so why can't they? So they are personally offended when a woman says no.'

I'm quite willing to accept that this last attitude contains a good deal of provocation. However, my statistical findings prove that it is more widespread than it seems, and that fear of

115

getting their knuckles rapped is the only thing keeping men from expressing it more often. Spoiled kids no longer systematically get the bean in the cake on *La Fête des Rois.*[6] Panic city! The defence is rallying. The War Measures' Act will soon be imposed. But not before Striking For Love.

Meanwhile, in Manitoba, they're defending themselves against the *French Power* threatening *Canadian* integrity.[7]

Your friend,
Roxane

Translator's Notes

1. *Female Power, French Power:* in English and italics in the text.

2. *one:* in italics in the text: *on* – 'one' – meaning women without referring to them gender-specifically.

3. Allusion to Molière's 1659 play *Les Précieuses ridicules* satirizing *Les Précieuses,* a group of bourgeois or aristocratic Parisian women who, from 1650-1660 principally, rebeled against their fate: enforced young marriages to older men and multiple pregnancies. Having also understood the link between women's inferior place in the world and in language, they attempted a linguistic reform which is a prototype of contemporary feminists' efforts to 'feminize' French. They were of course the object of much vilification. Molière termed them *ridicules* because women weren't supposed to discuss ideas and to tamper with man-made language. *Les Précieuses* have been reclaimed by French-speaking feminists. In English see Dorothy Anne Liot Backer, *Precious Women* (New York: Basic Books Inc., 1974).

4. *'contre'. . . ·tout contre·:* 'against/right up against,' as in 'close up' – a wordplay often used to reduce the relationship between women and men to sex, erasing all political connotation.

5. *cité-libriste:* characteristic of *Cité Libre,* see the Sixth and Ninth Letters.

6. *La Fête des Rois:* occasion of the traditional cake eaten on the feast held January 6, the Epiphany or feast of the Magi, or Twelfth Night. It contains a bean or pea sought after by participants in order to choose who will be crowned queen and king of the feast.

7. *French Power, Canadian:* both in English and italics in the text.

117

ELEVENTH LETTER

April

Have you ever heard of Manitoba? That's where, recently, the War of Troy did not take place.[1] The enemy was wiped out by being silenced and gagged, like in horror films. 'Speak White' the enemy was openly told. The enemy? Six percent of French-speaking people in a province that, when it entered the Canadian Confederation in 1870, was bilingual – meaning it had a Francophone majority. In 1880, a law passed by the Manitoba Legislature decreed unilingualism but it was declared unconstitutional by the Supreme Court of Canada almost a century later, in 1979. In 1980, a Manitoba lawyer tried to have the principle of bilingualism applied by protesting a parking ticket delivered in English only. Again, the case was brought before the Supreme Court. In exchange for promises to modify the provincial constitution so as to guarantee Francophone rights, Manitoba's NDP Premier William Pawley got the lawyer in question to drop the case. Then things took a turn for the worse. Pawley got his back up, showed his claws, caterwauled loudly in the direction of Ottawa, but ultimately retreated when faced with the barking of mongrels that sounded like wild beast cries.

The Trojan horse is everywhere: its name is Trudeau, Lévesque, Jacques Cartier, Louis Riel, Gabrielle Roy and especially Saint Boniface, the heart of Francophone culture in Manitoba, what with its *théâtre Molière*. Convinced of the threat of French domination, as subtle as Ulysses' arguments, as tenacious as bacteriological warfare, the 'Canadian' lion roars.[2] He uncovers a vast conspiracy on the part of the latin Western world against WASPs. The defence organizes: vandalism, intimidation, insults. The government yields to public opinion. Trudeau resigns. The Conservatives' new 'national'

leader, Brian Mulroney, educated in English in Baie Comeau, P.Q., doesn't dare compromise himself. The matter has been heard, the case is closed. One of the Francophone leaders is interviewed on Radio-Canada news: shoulders hunched, speaking with difficulty, like a hostage who has a gun pointed at his temple from backstage, he manages to say that the situation isn't desperate. Little by little, people's fears are calmed and things get back to normal, i.e., to the normal silence.

So the Trojan War did not take place. Because in these terribly unequal power relations, the die was cast a long time ago. The Trojan horse of *French Power* was entirely fabricated, the better to burn its effigy on the altar of hate.[3] For what struck observers of this odyssey was the extreme violence of reactions to this affair. I've always suspected that the Anglophones and Francophones of this country were more diametrically opposed than the Chinese and the Senegalese. For doesn't reconciling opposites and consenting to differences in fact allude to some immediately possible common ground? While the gap separating Canada's French-speaking and English-speaking populations is something I feel more and more as a tragic imperviousness. When asked what I think of Québec's cultural specificity, I reply: 'Come with me, let's cross the border and go to a small *Canadian* town, any one at random.[4] You'll find less in common there between those sons of Puritan Loyalists and the *Québécois* than between the latter and any nation in America or Europe, including England.'

The Manitoba question goes much further than the language issue. The hostility is directed against the very existence of Francophones, inasmuch as that existence must, in order to sustain itself, be accompanied by a certain number of rights or powers. A scandalous, completely illogical existence. Denied by the Right in the name of efficiency and by the Left in the name of social priorities. Denied by all in the name of a deeply visceral *je ne sais quoi*. Francophones are America's ETs. With the difference that no talented filmmaker has yet succeeded in

making the world feel for their story, which is becoming a very grievous epic.

At first, many *Québécois-es* were skeptical of the 'struggle' in Manitoba. To what extent, they wondered, will official bilingualism cancel out forces of assimilation so powerful that among the six percent of the population identified as Francophone, forty-four percent have already given up speaking French at home? Seeing the outburst of violence against these poor lost lambs accused of disturbing world peace and of causing infant mortality, those who had believed in the possibility of 'coast to coast' bilingualism – the sixty percent of *Québécois* people who said No in the Referendum – were very much taken aback.[5] What they had always interpreted as tolerance or fair play was a cold war that degenerated into a fight to the finish. Manitoba's settling of scores has a double target: punish Trudeau for his bilingualism and René Lévesque for his French Québec. In Canada, you buy peace in English because 'it's the universal language.'

The moral of this story is that Québec remains the only province submitting to the authority of a court of law: after Bill 101 was declared unconstitutional, the *Québécois* government accepted bilingual courts again. The only province, therefore, where the principle of bilingualism becomes operative and where the minority – Anglophone – isn't done out of its rights, despite its claims to the contrary. The moral of this moral is also that Québec remains the only place in America where it is – still – possible to live in French. What has been called Québec's retreat (*le repli Québécois*) – which was in fact not a falling back but a will to redefine the rules of the game on its own terms – has increasingly become a necessity and a way of affirming a presence in the world. 'Let the bastards go home' read the walls of the University of Toronto the day after the PQ was elected.[6] The same 'invitation' was recently extended again: 'In the spring of 1980, French-speaking people of Québec bet on being able to establish themselves in French in

Canada; in the fall of 1983, Manitoba Anglophones let them know that "people who want to live in the French culture [should settle] in Québec" (Lise Noël). How long will it take for the people of Québec to realize that they don't have to ask for permission anymore, that they've acquired the legitimacy of their self-determination? 'The liberties we want, we must take without further ado,' writes sociologist Marcel Rioux.

No comment from Manitoba. Will Québec do the same in time – but in how much time? A few weeks ago, a large colloquium on francophone literatures in America was being organized. But from Sudbury, the director of the Théâtre du Nouvel-Ontario declared that the French fact had only ten years left to live. Writer Jean Forest's account in *Le Mur de Berlin, P.Q.* describes the humiliations and discriminations suffered by a Francophone studying in that same so-called bilingual city of Sudbury.

There is no one, unless they've chosen the path of daily heroism, who dares to buy the French newspaper in a public place because 'French must be kept hidden. Like private parts and wet dreams.'[7] *L'Acadie* carefully keeps quiet. From the United States comes a television news item showing a community of Francophones who confess to having kept their language and their traditions alive: except that I can barely understand them. Is that the *francofunny* on whose behalf they justify the muzzling of Quebec?[8]

Trudeau quits and once again opposes centralizing logic to 'cultural intimacies.' Heirs to the throne don't quite know what to base the Great Canadian Fiction on. They're all alike in their sort of complete anonymity and total lack of what might be construed as an idea. So true to the image of Ottawa, the capital city that turns into a no-man's land as soon as you leave the veddy British prestige of the Parliament buildings.

In Québec there's a certain restlessness in the air and preparations are under way for the celebration of the four-

hundred-and-fiftieth anniversary of Jacques Cartier's arrival. While awaiting the tall ships, festivities kick off in France. L'Orchestre symphonique de Montréal is invited to perform in Paris. Radio-Canada TV news shows its Swiss conductor, Charles Dutoit, directing a rehearsal in English. The next scene shows Canadian dignitaries invited to the concert but forgets to mention the Québec delegation. In Saint Malo, the Ottawa representative tries to steal the spotlight from René Lévesque. But the French Minister of Culture warmly welcomes his *Québécois* counterpart.

The sun is shining brightly. Since my last letter, the maple trees have started running and everyone is going on their ritual outing to the *cabane à sucre* for a sugaring-off party where they will feast on baked beans, *oreilles de christ* and ham cooked in maple syrup.[9] In Québec, spring always arrives unexpectedly, without warning, after a storm. You wonder if you can believe in it, if it isn't just an optical illusion. You've hardly had time to adjust and it's summer already.

A Montrealer just won an Olympic gold medal in speed skating: he was given a triumphant homecoming. Encouraged by the large local breweries, many people are now avid fans of the hockey games pitting the Québec Nordiques against the Montreal Canadians. Personally, I confess I've a bit of difficulty getting interested in TV sports.

In a hardware store the other day I made a few comments about a poster advertising in English only. The salesman made light of it, said it didn't bother him.

Basically, it doesn't bother me either. So why should I bother making it my business anyway?

Ciao,
Roxane

123

Translator's Notes

1. Gauvin is referring to *La Guerre de Troie n'aura pas lieu,* a 1935 play by French writer Jean Giraudoux.

2. 'Canadian': in English in the text.

3. *French Power*: in English and italics in the text.

4. Canadian: in English in the text.

5. 'coast to coast': in English in the text.

6. 'Let the bastards . . . ': in English in the text.

7. Jean Forest, *Le Mur de Berlin, P.Q.* (Montréal: Editions Quinze, 1983). Translation mine. See also the Ninth Letter.

8. *francofunny*: in English in the text; Gauvin is punning on *francophonie.*

9. *cabane à sucre*: large cabins in the woods where the sap is collected, the maple products produced, and sugaring-off parties are held.

 oreilles de christ: literally, Christ's ears; a traditional way of preparing pieces of pork which, when fried, curl up in the shape of ears.

TWELFTH LETTER

May

I'd like to talk to you about my women friends. Neither *femmes flambées* nor *femmes gauchères*, they navigate as best they can among their multiple *appartenances*.[1] Often conflicting. Sometimes contradictory. When they tried to put their newfound freedom into action they felt trapped. Not so much by theory or by the native tongue as by the languages that make it an actuality. They came up against what can only be termed your everyday garden-variety sexism.

The words used to express reality are just not the same ones. It took me a while to understand that when they say a woman is a shrew and that a man has quite a character, they're saying the same thing: both have a bad temper. That when a woman is accused of being ambitious, it's a translation of what, in men, is called the desire to 'make his mark in history.' That what is called eclecticism or scatteredness in women becomes versatility in men. That men's exhaustion is due to the fact that they're working themselves to the bone while women's exhaustion is caused by faulty personal organization. And what about seduction? Isn't it seen as shameful manipulation when women do it, while for men it becomes an important diplomatic advantage? I'm slowly getting used to this kind of simultaneous translation. It's all done very subtly, very 'nicely,' as Marie-Pierre pointed out to me the other day.

After yourself, Marie-Pierre is my best friend. Together we go to places where modernism revisited by parody is on display. She almost wrote her thesis on *Québécois* theatre, once upon a time, but had to quit due to lack of time and money. She has no steady job right now so she has to take on hundreds of small jobs to earn her living. Marie-Pierre lives with André, who is also a full-time freelancer. You rarely see one without the other. They're like peas in a pod, a couple with an

125

apparently uneventful life. I often go out with both of them and only meet Marie-Pierre alone when André is busy elsewhere. Kids? Later, they say, much later. In the meantime, Marie-Pierre babies André, reassures him, supports him, cooks delicious meals for him (he does the shopping) and makes herself available for his every wish. When she has to lock herself up for a few days to finish a rush job, she feels the need to apologize. Not because of some accusation, but because of André's distress. Slowly but surely, she starts refusing offers that would be too time-comsuming. Meanwhile André has become the head of a small research team. Quite 'naturally,' and almost imperceptibly, since they've been together she has been withdrawing. People rave about the harmony of their coupledom.

I also know Nathalie, a Master's student like myself. I don't see her much. At thirty-two she has just separated from her husband and divides her time between the daycare centre where she works, taking care of her two children, and the courses she takes at university. People say she has a lot of courage. But as far as she is concerned, she feels only deep exhaustion throughout her heart and body, a permanent tiredness she believes is visceral or ontological. Nathalie is as beautiful as Botticelli's maidens. And now, like them, she 'knows no man.' Where would she find the energy for seduction?

I sometimes see Mireille. She's very sports-oriented and takes me on all kinds of excursions. Although she's a feminist, she nonetheless tacitly accepts the other's absences, thus subscribing to the implicit premise that it is in man's nature to go out and in woman's to wait. People think of her as generous, devoted, perfect. She never comments nor contradicts. Like a doting mother who looks the other way when her children misbehave. Like Maryse, before she started her process of self-discovery through writing. Also like any one of the many women in Sollers' novel *Femmes,* in which the hero is wel-

comed with open arms at every door. Mireille once told me she'd suddenly stopped expressing her grievances for fear that he would hate her. Mireille is a woman in love and keeps her mouth shut. Solitude scares her. She has also understood that she is stronger because of a certain image of patience which he envies.

Amélie tried playing all the roles and juggling everything: work, husband, motherhood, social commitment. Now thirty-eight, she is left with a terrible feeling of never being where she should be and, no matter what she does, feels hobbled by a vague and significant guilt. It was once made clear to her that she had best give up on the idea of having children. She stubbornly paid no heed. Given her line of work, she had to negotiate every little thing inch by inch. The slightest *faux pas* costs her, the slightest inattention is criticized as a crime of *lèse-majesté*. I know she turns down any business trip that would require her to be away from home for a long period of time. I also know she hesitates about devoting herself to projects of a more personal nature, ones unrelated to work, for she feels it would be on stolen time. And last but certainly not least, she's the one who, despite the principle of shared domestic chores, gets the blame when the supply of Kleenex runs out. This is quite a comment on the extent of her responsibilities.

This is how women live in a Québec threatened, so they say, by *Female Power*.[2] In a Québec where it's still easier to be a man than a woman. In spite of their exceptional dynamism, women here too remain at the mercy of codes, walking the tightrope between the *trop* and the *trop peu* (too much and too little), tethered to the necessity of being exemplary. Not a minority but treated as such by a history which either ignores them or points an accusing finger at them.

Does this amount to saying that all men are rapists, wife batterers, macho jerks? As for me, I've met only charming men. My long black hair and 'French' accent attracted them. I

127

was an other. Exoticism in your own home, what a luxury! Without really realizing it, I first started dating Married Men. Just because they were more available than the others, well aware that the only thing at stake in the affair was . . . an affair. MMs were especially courteous, civilized and sweet. They often invited me out to restaurants. But I soon found the scenario rather monotonous and, tired of solitary weekends, I became part of the circle of AMs – *Artistes Maudits* – always down-and-out, always unemployed, eternal pariahs of a society incapable of recognizing real talent. I'd gotten to the point of totally espousing their cause, of being politically active with them, of having them share my food, ashamed as I was of an affluence I'd done nothing to deserve. With them I spent entire nights making an inventory of possible utopias. Then I got to know the CSWs – the Comforters of Single Women. Be they bachelors or widowers, they basically provide a kind word and comfort. Something to cure all our blues. They too were very nice, very close to women, very understanding. Everything was fine till I realized that the same cassette recording was being used for a whole series of female receivers.

It was a while before I met Paul, whom I think will be pleased if I call him a man without qualities. Meaning that, like Musil's hero, he is liable to be interested in everything, curious about things and especially attentive to people.[3] A man without labels rather than without qualities. But isn't this just one more male privilege? The adjectives relentlessy affixed to the word 'woman' seem to me the thinly disguised avatars of a forever disappointed though ever-recurring quest for the Eternal Feminine. From *the* so-and-so woman to *the* this-or-that woman, such detours to avoid considering *a* woman in her all too disturbing individuality! Paul is one of the rare people for whom I don't need to represent some legendary fictional figure out of *A Thousand and One Nights*. Unless . . . How can I be sure?

[...]

I haven't told you everything about my women friends. For me, the nearest and dearest ones, even though I don't know them, are the ones who write and whom I've mentioned to you briefly before. I confess however that I'm not quite sure what 'writing in-the-feminine' is. I haven't had time to theorize on the subject yet, nor to locate the area of feminine/feminist/in-the-feminine literature within national/nationalist/general or universal literature. Nor to wonder what the specificity of *l'écriture-femme* – 'writing (as) woman' – is in Québec in relation to Canadian, post-Colombian or pre-Colombian 'writing (as) man.'[4] Nor to determine with precision the male component in women's writing or the female component in men's writing. That's not the real issue. Some women write, some don't. Some speak, some don't. Why? What are the forms of censorship, what are the prohibitions weighing so heavily, and even more heavily on women's self-expression than on men's? Increasingly, women are daring to break the language barrier, so to speak, if only to utter this inaugural sentence: I am not dead. The others suffer a slow and silent agony, reflecting the discourse of others considered normal, considered the norm. What we call women's subjectivity is something which is – still – not self-evident.

When women speak they speak to me, appeal to me, provoke me, make me an accomplice, an insider. If I have a problem with this question of the specificity of women's writing, it's that it seems to have an ontology as a point of departure, thus presupposing that upon arrival there exists a possible definition, i.e. something fixed and definitive. I have a feeling that, like the people of Québec, women are often told: yes, distinguish yourselves, list your titles and your symptoms, make the inventory of your differences, and *then* you can exist.

When I started spending time in the company of the singu-

lar plural of women's writings, I had to get used to simple hallucination. I saw faces instead of masks, restless bodies instead of truncated anatomies, desire where I was taught to see only rejection. A slight shift of my gaze and suddenly everything was other, both similar and different. I allowed myself to be carried forward by the innovative language of my contemporary sisters. A whole network of friendships through writing gets woven by the sentences of Noël, Monette, Villemaire, Gagnon, Brossard, Bersianik, Théoret, Jacob, Lamy and the others. Texts in which I focus on reading the feminine in the polyvocality of a kind of writing where, on the other hand, this feminine is never used as a token. Intransitive writing? Writing out of the frame? Does it even have this pretention? A mere change of lighting? I've often told you how much I like Madeleine Monette's meticulous dismantling of movement and inner drives, Madeleine Gagnon's tropisms, Suzanne Jacob's slow-motion cinema, Suzanne Lamy's theoretical benevolence, the knot of anguish stretched to the limit of the speakable in France Théoret's work, identities hanging on the split-second in Yolande Villemaire's fiction, and the intelligence of dailiness in Francine Noël: her *Maryse,* who is neither femme fatale nor *femme objet,* is a humorous 'take' on a civilization where males were (are) still the ones who spoke (speak), where males were (are) right, and where they appropriated (appropriate) the power to create the categories of relevance.

I believe there are 'circumstances' of women's writing, just as 'there are conditionings and conditions linked to women's existence' (France Théoret). These circumstances refer back to a 'multiple continent' (Nicole Brossard). I'll say it again, the women writing today are eclectic, ravenous, impertinent. Any effort made to lock them into the authority of a model or a genre will be in vain. For it was not in vain that they witnessed the death of God. Their goddesses are those of early mornings re-invented daily through language that is always as fragile as

it is bold. Women writing today are more than ravenous: they are greedy, literary pillagers drawing from the styles and trends that please them, provoke them, stimulate them. From modernism they borrow its deconstructions of language, its formal transgressions, its questioning. When modernism becomes too restrictive they turn to romanticism, i.e. the rehabilitation of an *imaginaire* in-the-feminine, the injection of desire, the quest for fusion. They are also inspired by postmodernism in their use of quotation and collage, in their tendency toward hybridization, the mélange of styles, and a new appeal to theory diverted away from its rigidity by humour and poetics. All these tendencies are identified and analyzed in a recent anthology entitled *Féminité, Subversion, Ecriture.*[5]

Though I need not be *Québécoise* to partake in this writing in the present tense, I don't believe in a transcontinental statelessness of literature in-the-feminine either. Isn't my reading already evidence of a particular journey? My Oriental antecedents make me tend to favour that which, in the texts I read, gestures towards the constitution of a new referent, of a new image.

Isn't leaving behind the stereotypes of the virgin, the mother, the whore or, closer to my own culture, of woman as *le repos-du-guerrier,* already quite an undertaking in itself?[6] It seldom happens that a change at the level of the referent doesn't also produce a structural modification. Take for instance Marilú Mallet's lovely film, *Journal inachevé,* where at the same time as the woman-subject is constructing herself, a new and different cinematic perspective is taking shape. Take also the texts written by the women I call my friends. By way of an 'I' often couched in the institutional humility of diaries or letters, they succeed in warping the codes, literary as well as social, and in bringing about *l'Existence,* to borrow the title of Carole Massé's latest novel.

Given the importance of tradition in our country, I'm also especially interested in the trend toward re-writing existing

131

texts. This is what Louky Bersianik did in *L'Euguélionne,* a re-visioning of the Gospel, and with *Le Pique-Nique sur l'Acropole,* which is Plato's 'Banquet' revisited.[7] Using pastiche, parody, free imitation, the aim is to bend the models, to transform them, to re-write them in the feminine. It seems to me that many famous masterpieces would gain from such a treatment. A more contemporary intertextuality is also revealing. As I situate myself in the Mallarmé-Ducharme-Villemaire chain, I can tell you that what I saw in this writing by women can be expressed by this new saying: *'La chair n'est pas triste et elles n'ont pas lu tous les livres'* – 'the flesh is not sad and women writers have not read every book.'[8]

Women quote one another, it's well known. They've discovered this as a way of gaining recognition for a manner of speaking *(parole)* that is otherwise very much denied. So you won't be too surprised if I close with a quotation myself:

> Acknowledging oneself as a feminist implies having reached a certain agreement with oneself when, according to the social climate, commitment is out of fashion [. . .] (Suzanne Lamy).

I would add that acknowledging oneself as a woman and a *Québécoise* implies an even better agreement with oneself on the part of women living here, given that both these identities – and the point is to not mix them up, of course, nor to blur them in false equivalences – elude the grasp of a certain discourse of power usually termed universal.

> I look forward to hearing from you,
> Roxane

Translator's Notes

1. *femmes flambées*: *La Femme flambée* is the title of the 1983 film by German director Robert Van Ackeren in which a woman literally goes up in flames at the end. The allusion is to exploited, used, victimized women.
 femmes gauchères: *La Femme gauchère* is a novel by German writer Peter Handke. The French title plays on left-handed woman, (*gauche* means left) and leftist woman. Here it refers to a liberated woman who leaves everything and starts her life all over again. In this context they are used both as opposite terms and as unrealistic female caricatures, stereotypes.

2. *Female Power*: in English and italics in the text.

3. Allusion to German writer Robert Musil's *The Man without Qualities*.

4. *l'écriture-femme*: woman-writing, writing (as) woman.
 l'écriture-homme: writing (as) man.

5. *Féminité, Subversion, Ecriture*, Lamy, Suzanne & Pagès, Irène, eds. (Montréal: Editions du Remue-Ménage, 1983).

6. *Le Repos du guerrier* (the soldier's respite): title of a controversial 1958 novel by French writer Christiane Rochefort.

7. *L'Euguélionne* (Montréal: Editions La Presse, 1976). *The Euguélionne*, transl. G. Denis, A. Hewitt, D. Murray, M. O'Brien (Victoria/Toronto: Press Porcépic, 1982). (Out of print.)
 Le Pique-Nique sur l'Acropole (Montréal: VLB Editeur, 1979).

8. Paraphrase of Mallarmé's famous observation: '*La chair est triste, hélas, et j'ai lu tous les livres*' – 'the flesh is sad, alas, and I've read every book.'

THIRTEENTH LETTER

July

I'll leave you with a landscape: Québec City, already nostalgic for its tall ships. Many people of good faith – people in this province are always of good faith and this is precisely its undoing – had believed in this celebration organized to the tune of millions of dollars as a tribute to the memory of Jacques Cartier. Each participating government took credit in an attempt to coopt the navigator's legacy into political capital. For fear of going unnoticed, Ottawa quickly dispatched its friendliest soldiers on location. I hear that in occupied Québec of 1970, the military was equally considerate.

It's hard to tell whether it resulted from a mistake in charting the course or from some strategic error, but the outcome was the same: the crowds disappeared along with the prestigious foreign ships. This was unexpected. In an attempt to re-animate the port's deserted site and to avoid general rack and ruin, further millions were injected. I'm beginning to understand that there is no understanding politics. While more millions rain on the mast of Montréal's Olympic Stadium (the world's most expensive stadium, as it were), angry teachers are asking for their old working conditions back and artists are fighting over the few crumbs granted them if they are patient, obstinate and (how interesting, this third element) 'excellent.' One day coffers are full and the next day empty. Might the State's budgets be purely metaphoric? Listen to me, I'm more *Québécoise* than I thought, for until now I'd succeeded in resisting my new compatriots' instinctive anti-government-control stance. I'm about to lose my mother tongue, all the more so since I recently got a taste of government bureaucracy. I'll tell you the story as faithfully as possible. You'll see that Oriental countries don't have the monopoly on the inextricable.

By chance, I read a notice about special funding I was eligible for, provided I put together a 'multi-media' team. For further information, I phone the government department in question. The first person I ask to speak to – the one whose name was featured in the notice – is in a meeting and his secretary can't say if it will be over today or weeks from now. Figuring that this person must be a very important civil servant, I don't leave a message. I call someone else, who admits that the programme's award criteria haven't been established yet but that the budget will nonetheless be spent within about a month and that they've already received three times more applications than there is money available. I enquire about how the programme can be managed when its conditions aren't even known, but this doesn't seem to bother him. He very pleasantly tells me to talk to someone else. Unfortunately when I try to reach that someone else, he is away from his office and does not return till late that afternoon. He sounds very enthusiastic about my project and promises to get me the information needed. Two weeks later I go to his office and find him quite distressed for having so little news for me. Isn't there somebody somewhere who can provide me with this precious information, I ask? He takes me to the office next to his: there I learn that yes, the programme does indeed exist, according to criteria that are both fixed and relative. You can even, says my female interlocutor, get a first grant to prepare the actual application and flesh out the project so as to demonstrate clearly its collective, multi-disciplinary and, if possible, international nature. I don't dare ask her about the conditions for this pre-grant funding. I'm just about to launch into the whole process with my teammates when I find out that my efforts will be in vain: there is no more money in the till. My conclusion is that it's better not to push it, while envying those with the know-how to get millions raining on a *Québécois* summer.

I'm convinced that this experience has nothing to do with

my foreigner status. With only slight variations, several friends of mine have been in similar situations. In fact, did I tell you I'll soon be getting my immigant's visa? I've decided to live here, despite the red tape, the stifled use of language, that eternal aching feeling about the other which is a reflection of that ache inside oneself, and a semblance of constant improvisation I call the culture of the immediate, with everything that this implies in terms of ability or incoherence, depending on the participants' skill (*arte*). In spite of or because of all this? Will I ever know for certain what attracts me to this place and keeps me here? I've learned to walk following the rhythm of this maelstrom, to make my own way in this very restlessness. In any case, I much prefer it to a form of self-satisfaction and the overstatement of codes elsewhere called civilization.

Are *Québécois-es* really xenophobic? I don't know of any other country in the world which has offered as many jobs, at every social level, to foreigners. Didn't I myself recently find a job with a local publisher? I've known Europeans, a French woman in particular, who after earning her living in Québec for seven years, went away full of sour grapes: doors had opened and closed, arms as well. What *Québécoise* arriving in France can boast of being able to settle there? Of counting on genuine friendships?

I'm getting ready to declare myself *Québécoise*. A strange investiture which, just in case you have any doubts, is nothing like a religious calling. *Québé-quoi?* some now ask.[1] The subtle harassment has paid off: you have to take precautions now when designating yourself as such. Canadians the day before yesterday, French-Canadians yesterday, today's hesitant *Québécois* have been the constant victims of semantic perversion. At the turn of the century, disoriented by the English who usurped their title of Canadians, all they could do was fall back on the qualifier and epithet, becoming French-Canadians in the interest of a harmless diaspora. In the Sixties and Seventies, when Québec attempted to perceive itself as a

137

whole, its self-definition was criticized – always the encyclopedist's mentality! – for not being the right one. Accused of being flawed in both form and content. Indeed, for weren't there Francophones to be found outside Québec and Anglophones in Québec? Wasn't this proof positive that Québec was a province just like all the others?

Recent political history could lead us to the conclusion that Québec's *indépendantiste* thrust ultimately only helped to consolidate 'Canadian' federalism.[2] But triumphalists should consider the fact that the unifying logic which, for all intents and purposes, amounts to a denial of Québec (where, remember, eighty-eight percent of the country's Francophones live), will sooner or later lead to the eclipse of all of Canada. There is something sick, on the part of the authorities in power in Ottawa, in pretending that they 'care about Québec' while refusing to give it the political, economic and social means to grow beyond mere survival.

I sometimes wonder, Sarah, if I'm not one of the few people in Québec today who is genuinely interested in Québec. Am I the New Wave entomologist come to study the rare species, all the more fascinating because it is becoming extinct? The *Québécois-es* are losing sight of themselves. The fog around them keeps getting thicker. Like during the Fifties, many are thinking of leaving, of going somewhere else, where the grass is greener, where every detail of daily life, every minute project, doesn't have to be discussed at length, negotiated, wrested from the lethargic hands of the powers that be, out of the ambient dullness and moroseness. Where every word spoken isn't de facto open to suspicion from within as well as from without.

Up until now I've succeeded in escaping this harassment. I continue to believe that Québec's destiny is neither derisory nor indeed specifically *Québécois*. In fact, isn't the rubbing out of cultures one of our contemporary world's more distressing problems? Doesn't the 'global village' utopia actually mask a

thinly disguised form of centrist and standardizing discourse? If you don't control the levers determining its impact, doesn't access to a modernism increasingly tied to the media, information and technology run the risk of being fake? And what is the meaning of ecology when a large part of the world's economy is in the hands of multi-nationals? And finally, what will become of vernacular languages lacking the powers underlying their usage? Power also means will to power. Is this privileged laboratory called Québec sentenced to feigning like the ostrich and to faking like the chameleon?

Increasingly skeptical, *Québécois-es* know that the *virage technologique* (swing towards technology), the latest government slogan, hasn't remedied a thing. Increasingly sensitive to clichés, they now know that between paternalist France, always a little self-interested, and the America of ever bigger and cheaper Big Macs, they don't have to choose. By way of America the normal and banal, they're learning to recognize America the strange and marginal. Like the characters in *Volkswagon Blues,* Jacques Poulin's latest novel, they're setting their own course, mapping out their own networks, seeking to invent signs for their own reading. To One America they prefer the multi-dimensional reality of friends to the south with whom they're discovering ties. Over the France of *petits marquis* (as in *petits bourgeois*), still jealously guarding its hierarchical order, they choose a less haughty France, i.e. the independent, ex-centric places far from the 'nouveau Versailles' which some Paris quarters have recently become.

But *les Québécois-es* haven't quite yet managed to integrate this broadening of the framework into their analysis of their own image. They've internalized the discourse of the other – the 'Canadian' – who has them convinced their questions are irrelevant and their necessities ethnocentric.[3] So they withdraw, gaze at themselves in the mirror and, spotting a blemish on their left cheek, decide to smash the mirror. In a recurring and almost atavistic way, they have gotten into the habit of

directing their bitterness against themselves. A recent example, sadly pathological, seems to me very telling.

Just when the media is falling all over itself with praise for Trudeau following his departure, Denis Lortie, a young corporal born in Québec now living in Ontario, tries once and for all to vent the frustrations accumulated during his regular contacts with Anglo-Canadians. Armed with a machine gun he bursts into the Québec National Assembly one morning, intent on shooting at 'anything that moves.' But he has arrived ten minutes too early and misses his targets – ministers and members of Parliament – so he ends up hitting only a few security guards. Object of a thousand humiliations, victim of an insidious indoctrination, Denis Lortie can think of nothing better, to atone for the sin of his own birth, than to carry out the murder of the father. Suicidal insanity, granted. But how very symptomatic, in varying degrees, of what I've noticed around me.

[...]

You suggest that I publish my letters because, as you put it, a distanced perspective is sometimes useful for bringing people back to self-consciousness.... One day I'm tempted to do it and the next day I pull back. Because, due to my origins, won't I be locked into a comparison with my famous predecessor?[4] Will people understand that it's almost a coincidence? While I do think there is a certain modesty in inscribing oneself in the endless variations of literary genres and styles, I also remain convinced that one cannot play with references without deeply altering perspective, without emphasizing distance.

We are no longer astonished by the same things. Our desires, however, haven't changed much.

Yours ever faithfully, Persian by birth and *Québécoise* by adoption,

Roxane
1982-1984

140

Translator's Notes

1. *Québé-quoi?*: wordplay meaning Québec-what?
2. 'Canadian': in English in the text.
3. 'Canadian': in English in the text.
4. Reference to Montesquieu (1689-1755), the French philosopher, author of *Lettres persanes* (1721) in which he brilliantly satirized France. An excerpt from his book frames Gauvin's *Letters*, a genre particular to French literature.

ODETTE DESORMEAUX

LISE GAUVIN, literary critic, essayist, and short story writer, is a professor of literature at the University of Montréal. She is on the editorial boards of *Possibles* and *Questions de culture*, and was president of the Association des éditeurs de périodiques culturels Québécois from 1984 to 1986. Besides publishing a study of the Sixties, *Parti pris littéraire*, she has edited several books and journal issues, has prepared radio and television literary broadcasts, and has contributed to the collections *Qui a peur de...* and *Montréal des écrivains. Lettres d'une autre* is in its fourth edition (a TYPO paperback) and *Ecrivains contemporains du Québec*, an anthology of Québec contemporary literature co-edited with Gaston Miron, has just been published by Seghers, Paris.

SUSANNE DE LOTBINIERE-HARWOOD is a Québécoise who writes and translates in both English and French. She has translated several Québec and Canadian feminists including Alonzo, Brossard, Cotnoir, Marchessault, Marlatt and Scott. Her work has appeared in both Canada and the United States and in 1981 she was the first recipient of the John Glassco Translation Prize. *Re-belle et infidèle/The Body Bilingual*, her dual language book about translation as a re-writing in the feminine, will soon be published by L'Essentielle éditrices, Montréal.